PARANORMAL
COUNTY DURHAM

PARANORMAL
COUNTY DURHAM

DARREN W. RITSON

AMBERLEY

This book is dedicated to all the good folk of County Durham

First published 2012

Amberley Publishing
The Hill, Stroud
Gloucestershire, GL5 4EP

www.amberleybooks.com

Copyright © Darren Ritson 2012

The right of Darren Ritson to be identified as the Author
of this work has been asserted in accordance with the
Copyrights, Designs and Patents Act 1988.

British Library Cataloguing in Publication Data.
A catalogue record for this book is available from the British Library.

ISBN 978 1 4456 0650 7

Typeset in 10pt on 12pt Sabon.
Typesetting and Origination by Amberley Publishing.
Printed in the UK.

Contents

By the Same Author

Ghost Hunter: True Life Encounters from the North East
In Search of Ghosts: Real Hauntings from Around Britain
The South Shields Poltergeist, One Family's Fight against an Invisible Intruder (with Michael J. Hallowell)
In Search of Ghosts: Real Hauntings from Around Britain
Haunted Newcastle
Ghost Taverns: An Illustrated Gazetteer of Haunted Pubs in the North East of England (with Michael J. Hallowell)
Paranormal North East
Supernatural North
Haunted Durham
Haunted Berwick
Ghosts at Christmas
The Haunting of Willington Mill (with Michael J. Hallowell)
Haunted Northumberland
Haunted Tyneside
Ghost Taverns of the North East (with Michael J. Hallowell)
Haunted Carlisle

Acknowledgements

I would first like to thank Malcolm Robinson for penning the foreword to this volume: your kind words and your support over the years have been really something and is very much appreciated. Thanks Mal. To my good friend Mike Hallowell for his usual ongoing support and help; to Drew Bartley, Fiona Vipond, Mark Winter and Paul Dixon; to Andy Local and Craig Best; to Dave Shaftoe of the Bonny Moorhen pub in Weardale for allowing overnight access to his wonderful pub; to Keith and Maggie Bell from Crook Hall for their kindness and hospitality during my visits there; to Cindy and Colin Nunn and to all the volunteers at Hurworth Grange in Darlington for allowing me in to spend the night there; I extend my thanks to Cindy and Colin, as well as the owners of Harperley POW camp, for again allowing me access to the site to assist in the paranormal investigations that took place there – *one* of my nights there is a night I will never forget. Also, to Paul Mash from the Garden House pub in Durham City for allowing me in to investigate his premises and for telling me all about his ghostly goings-on; to the owners and staff at Beamish Hall; to the owners of the Manor house in both Ferryhill and in West Auckland; to Michael Carter from Durham who informed me of his strange encounters at the manor house at West Auckland; to museum manager, Dave Tetlow from North Road Station in Darlington for your hospitality and kindness during my visit there; to Yvonne Moore, her sister Margaret Wilkinson and *her* husband, David Williams from the Dog and Gun Pub in Bear Park, for allowing overnight access to the pub for investigations. To Karen Hague, Adam Hague and Meg Armstrong from Witton Castle for allowing me in to investigate and for sharing all their ghost stories with me for this volume; to Ian Howarth for allowing overnight investigations in his 'lock up' and for sharing all his ghost tales with me; to the staff at Killhope Mine for allowing overnight access and for also sharing their ghostly stories with me; to Paddy Solan from the Shakespeare Tavern in Durham City for taking time out to talk to me during my research; to the owners and staff at Preston Hall Museum, and to Richard Felix for making my night there one to remember; to Kenneth Madison from High Rigg House Farm in St John's chapel for relaying his ghost tales from his old farmhouse and for allowing overnight investigations at his wonderful home; to fellow author Rob Kirkup for his use of the Preston Hall Museum image; to Andrew Local for usage of a number of his images of Witton Castle; massive gratitude must go to C. J. Linton, a paranormal historian and investigator from County Durham for his co-operation and his kindness during the compilation and research for this book and for allowing me to reproduce ghost stories from his website along with some of his own photographs of haunted areas of Durham; thanks must also go to the Newcastle Libraries and Information Service for the use of a number of old images produced herein.

Foreword

I've been involved in UFO & Paranormal research for many years now. Not only have I participated in investigations, but I have read quite a substantial amount of books by many different authors, each of which have their own take on what constitutes being a ghost. And *there* is the rub: paranormal investigation is not so cut-and-dried as one might think. It's not a case of pointing a camera at a wispy column of mist that has suddenly appeared before you, capturing it on film and going on to claim that you have captured a ghost. *Investigation* means just that. One has to open as many doors as possible to find the definitive answer of which there isn't always an easy one.

Ghost investigation is a process of trial and error; equipment can be used but sometimes it is just down to your own five senses of sight, sound, touch, taste, and smell to bring you answers. When I started in the field of ghostly research, there were hardly any television programmes on ghosts and hauntings. My, how times have changed; we have literally a plethora of television shows all aimed at Joe Public to show how fascinating ghosts can be. Sadly, quite a lot of them are pure entertainment and nothing else, but at least it has brought this amazing subject to the attention of the masses. Like me, however, the author of this book was investigating ghosts and hauntings long before 'ghost fever' took a grip on the nation, or indeed the entire planet.

I remember just over twenty years ago in the early 1990s when I lived in Alloa, a small town in central Scotland, the author of this book wrote me a letter, asking me how he should go about his investigations into ghosts and UFOs sightings, an avenue that he was treading down for the very first time. Reading Darren's letter it became apparent that this young man was more than dedicated; his passion shone through with every sentence that I read and I could see, even then, all those years ago, that Darren would turn out to be the fine ghost investigator that he is today. I suppose I shouldn't be that amazed, as this young man has not just written two or three books on his passionate subject, he has written almost twenty (some of which were co-authored) and he has, I believe, a number of other exciting book projects on the way. Maybe this is not so much an astonishing feat for a young man, whose sole purpose is to find out the truth of ghostly sightings across Britain.

I have read many of Darren's books and I have to say, without exaggeration, he is *the* best author on the subject of ghosts that I have ever read. Not only does Darren bring the stories together, he paints the picture for the reader by probing the facts, figures and history of the locations that he has visited, all of which goes to present to the reader how this ghostly tale came into being. This current book is no exception and will hold for you the reader a journey into the strange world that is ghosts and spirits. He takes you on a guided tour of County Durham, an area which has seen more

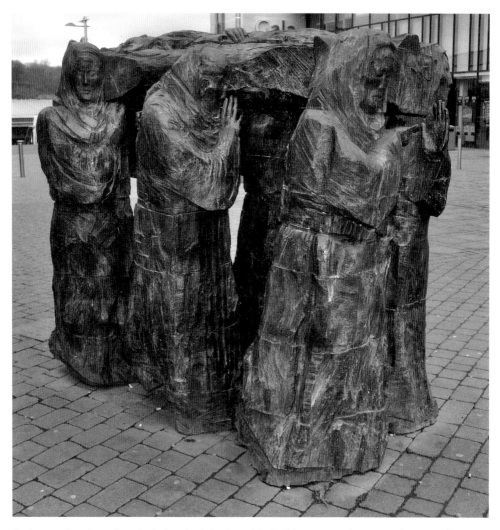

An impressive piece of art depicting the 'bringing of St Cuthbert' to Durham. Standing in Millennium Square in Durham city, it is known as *The Journey*. It was made by the artist Fenwick Lawson.

than its fair share of ghosts. Britain is said to be the most haunted country on Earth and I would tend to agree with this statement. There is no denying that the history of this country is awash with intrigue, murder and treachery. I remember reading a book many years ago entitled *Bloody Britain* and goodness me, that book surely brought it home to me just how *bloody* Britain was in days gone by.

Needless to say, this has left a residue, an imprint if you like, of places and buildings across our great land. Darren has in previous books looked at various towns and cities across the UK which boast ghostly manifestations and this new book is just as good, if not better; it explodes with case after case that brings home to you, the reader, just how grisly ghost sightings can be. But not just that, it's also more to do with the lasting imprint that it leaves on someone who has been unfortunate (or fortunate) to have seen a ghost. People may laugh and scoff at these things but there is no denying that they

exist; but do ghost sightings imply a proof of a life after death? Or are these visions of people merely some kind of etheric video tape replay?

Darren W. Ritson provides the reader with some amazing ghostly tales within this book. He has been assisted on his ghostly journey by a number of different ghost investigators throughout the years; none more so than his longstanding friend Michael J. Hallowell, another fine researcher and author. Darren can count himself lucky to have found the Paul McCartney to his own John Lennon. Both men have worked tirelessly travelling around the UK chasing ghosts, but moreover, and more to the point, both Darren and Mike has raised money for many charities by carrying out their ghost hunting. Now that, in my eyes, is not just a magnificent deed but a kind and caring gesture to show that raising money for charity can come about in the most unusual ways; and God bless the pair of them for that. I heard once that Darren alone raised over £1,500 in one night during an investigation in his home town of Newcastle for a local children's heart charity.

As for this book, well, Darren informs you that one of his favourite haunted locations in the county of Durham is Crook Hall; not so much for its ghosts but also for its splendour. Its buildings and gardens are magnificent. One tends to think that ghost research finds you in old ruined castles and cold and windy churches etc., not so, sometimes, as with the ghosts of Crook Hall, one finds themselves in an environment which takes the sting out of experiencing ghosts. Another location which Darren truly enjoyed was his evening at Lumley Castle in Chester-le-Street, where he participated in an authentic-style Elizabethan Banquet. On another occasion he stayed there overnight hoping to encounter the ghost of Lily of Lumley for himself. For anyone coming into the subject of ghosts for the first time this will be a fine read simply because of the way in which Darren writes. You feel that you are physically right there with him in that haunted room and that you are stood facing the ghost that he is telling you about. The spine-tingly atmosphere that Darren evokes into these true ghost stories leaves you with a grasp of how it must be like to witness a ghost. A remarkable skill for a writer to have and ones which makes Darren's books so fascinating to read.

Ghost investigators come and go. Some come into this field of study for the thrills, and when those accompaniments don't manifest (as most often they don't) they move on to other things. Not so with Darren. Darren has spent many hours sitting in darkened gloomy halls waiting on 'something' to happen; invariably it doesn't. Ghosts don't always materialise at the flick of a switch. Any ghost researcher will tell you (including myself) that nine out of ten investigations will yield nothing, but it's that tenth one – the one where something does happen – that makes it all worthwhile. Darren W. Ritson joins a growing band of forerunners; pioneers in this field who are searching endlessly for answers not just to questions such as *why* people see ghosts, but more importantly as to what 'is' an actual ghost. As you go through this book you will see that the county of Durham holds many ghostly tales and by the time you have finished this book you'll come to realise why people like Darren W. Ritson can be so fascinated by tales of the Supernatural. So sit back, pour yourself a glass of wine and enter the strange arena that is ghostly Durham, but before you do, is that draught you feel really an open window, or could it be something else? Enjoy the book. I certainly did.

Malcolm Robinson

Introduction

Before we begin I would like to say that researching ghosts and investigating tales of the supernatural is a tough business. In this respect I mean that whatever your chosen methods of paranormal investigation and research you will never please everyone; you are damned if you do, and you are damned if you don't, I have found. When researching ghosts you have to be as honest and as objective as one can be and must try not – under any circumstances – to hold any preconceived ideas about haunted locations and ghosts that may inhabit them. The vast majority of cynical individuals – namely sceptics – say that most believers will more often than not jump straight into paranormal conclusions when a so called incident occurs; they *want* it to be a paranormal incident, therefore they will naturally note it as such.

Well, it cuts both ways! I put it to the reader that, when *sceptics* spend time in a haunted location, how is it deemed acceptable by folk for them to automatically jump to the 'it was *not* a ghost' conclusion? Nine times out of ten, they do; double standards at its worst. My point is, being a sceptic *or* a believer is, in essence, going into a haunted locale with a preconceived idea. Therefore, I feel it is best to enter into investigations with an impartial approach and evaluate any occurrences as, when and *if* they happen. This is what I try to do when investigating claims of the paranormal, so if I make any errors or inadvertently jump to what could be deemed as a hasty conclusion, based on the fact that I do believe, then I can only reiterate that at least I *try* my utmost to remain neutral. I am only human, after all, and I am still learning as I progress through the years.

That said I would now like to press on. A few years ago I penned a volume called *Haunted Durham* and, in preparation for that, I spent some considerable time in Durham city. During my research there I discovered a wealth of fantastic tales of ghosts, poltergeists, spectres and spirits, and an abundance of folkloric legends and other harrowing tales of the supernatural. After completing the book on Durham city, I wondered just what else this fine northern county had to offer in the way of paranormal phenomena, and I was more than pleasantly surprised. When I began to compile this exciting new volume, little did I know at that time that I would discover – and to a certain extent, unearth – such a wonderful new range of the paranormal that not only goes a small way to enhancing our understanding of it, but also adds to our extremely rich and wonderful northern haunted heritage. To pen this volume has been yet another great privilege as it has given me a great opportunity to 'get out there' and explore this magnificent county. The county of Durham (or County Durham) also known as 'the Land of Prince Bishops' is an area of outstanding beauty that is primarily

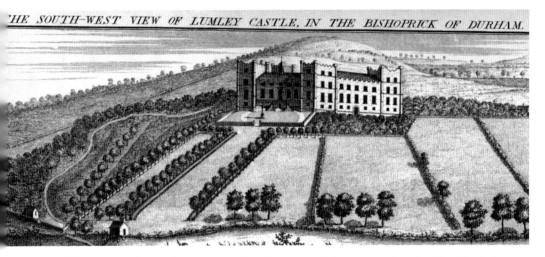

An old illustration of one of County Durham's most well-known castles: Lumley Castle in Chester-le-Street. Lumley Castle has a number of ghosts and features later in this book. (*Picture courtesy of Newcastle Libraries and Information Service*)

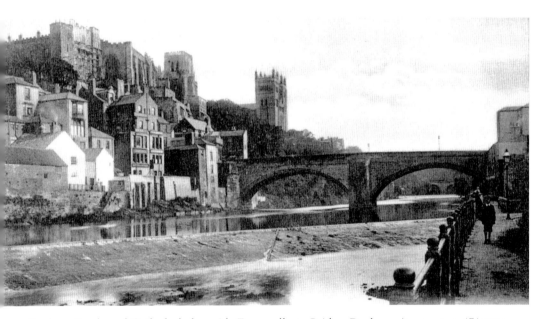

Durham Castle and Cathedral alongside Framwellgate Bridge, Durham city, *c.* 1910. (*Picture courtesy of Newcastle Libraries and Information Service*)

recognised for its lead mining and farming industries. A combination of rolling hills, quaint little countryside villages, townships and a historical city as its capital so to speak, County Durham is a stunning region to behold.

The ghosts here are aplenty and they are festooned far and wide. We have ghostly galloping steeds and harrowing horseman silently making their way across the moors and hilltops; priests, monks and other god-fearing men eerily frequent in the many religious buildings that are scattered hither and thither around the county; poltergeists plague people and their places; old pubs and inns are bursting at the seams with long-dead patrons, and ancient battles that were once fought here are being silently fought again much to the bewilderment of those that see them or indeed, hear them. So wherever you endeavour to go in the wonderful County Durham, whichever way you turn, you can be sure a ghost will lurk in almost every corner.

Ghosts, my faithful friends, are indeed a reality and anyone who is prepared to seek out and study the vast amount of literature and the bona fide case studies and evidence that have been accumulated *en masse* over many hundreds of years will soon discover this for themselves; it is hard to come to any other conclusion. Those that flatly refuse to accept the proof of ghosts are, more often than not, the individuals that have failed to study this evidence. One day, however, when you are out and about and when you least expect it – whether you believe in ghosts or not – you may just run into one of the many spectres that inhabit County Durham or, indeed, the UK. You may be on a bus, in a pub, taking a stroll in the countryside, it matters not – they are everywhere. It could be just a matter of time before you come face to face with one yourself; happy reading…

1

The Ancient Unicorn Inn, Bowes

Nestling high in the North Pennines, the village of Bowes is a picturesque, rural community, home to a wonderfully haunted alehouse known as The Ancient Unicorn Inn. Wonderful views of the countryside and its outstanding natural beauty can be observed from this superior vantage point. It is thought that the acclaimed writer Charles Dickens once stayed here while he was researching one of his many novels; indeed, the room at the hotel where it was thought he stayed is named after him.

The old inn, like a lot of pubs, dates back to the sixteenth century, and similar to most old taverns and watering holes it began its long and historical days as a coaching inn. This pub, by all accounts, is 'quite haunted', and has featured in a number of television programmes and books with the legends of its resident spectres being told in full for all to enjoy. It is reputed to house a number of ghosts, more than the average alehouse normally has, and has attracted the attention of some of the North East's enthusiastic 'spook spotters'.

Visitors to the pub often report feelings of being touched and pushed when no one else is around, and sense a presence when they know for certain that they are alone. Patrons that stopover in the hotel have also experienced the same aforementioned phenomena, along with hearing strange and eerie noises such as unexplained footsteps along the corridors in the dead of night. There is also the ghost of a man that has been seen wearing a bowler hat, and an unidentified ghost boy that has been seen in the cellars in the bowels of the property. One particular ghost story, however, that dates back to the early 1700s, is by far the most famous tale attached to the Ancient Unicorn and is a very sad account of a young couple's love that was destined never to be.

Martha (more commonly known nowadays as Emma) fell in love with a boy, the son of the landlord and landlady of the neighbouring public house (now sadly long gone). Their love affair was not approved by their parents and a ban was swiftly enforced in an attempt to cease their relations. Ultimately, their liaisons had to be, and were indeed, carried out in secret.

It was a relationship ill-fated from the outset. Soon after they began their affair, Emma's beloved fell seriously ill with a fever, after becoming caught in a storm on the desolate moors, and subsequently died. Emma, suffering from a broken heart, is said to have died only a few days later. They were both interred together in the local cemetery where their final resting place can still be seen today. Emma is reputed to 'walk' the corridors and rooms of the Ancient Unicorn and has been seen by many people while staying over at this wonderful pub. She is said to be a 'friendly soul, but very sad nonetheless'.

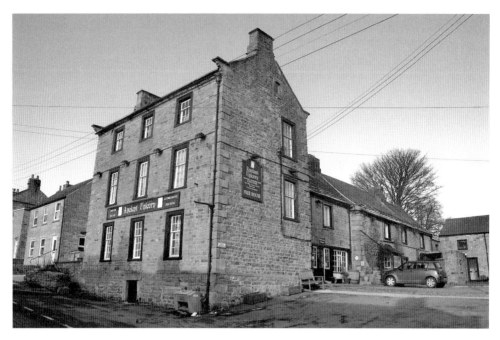

The old haunted pub known as the Ancient Unicorn Inn. Situated in the village of Bowes, this old inn lays claim to a number of ghosts including a spectral man in a bowler hat, a young phantom boy down in the cellar, and most famously, a broken-hearted young girl named Emma.

In 2004 a reputable paranormal research team based in the North East carried out investigations here at the inn and reported a number of strange happenings. A shadowy figure was reputedly observed standing in a doorway but disappeared altogether when the witness focused his eyes hard upon it. This figure was said to have been observed yet again later on in the investigation in the same doorway and once again it vanished from view when focused upon. Although photographs were taken at the time, it was reported that this figure sadly never showed up on them. Other activity that can be deemed as 'odd' was also recorded by the team; a jar of sweets that had been left on the bar was heard to rattle on *two* separate occasions and when no one was near it at the time. The shuffling of feet was heard by a number of investigators while carrying out a vigil in the restaurant area, and another investigator reported that something tugged at his clothes for no less than fifteen minutes while sitting in the darkness. He is adamant that there was nobody next to him at that time; very interesting to say the least. These accounts and other reports of the paranormal activity that have been noted here for many years really do go some way to supporting the theory that this fine old world pub-cum hotel, could really be frequented by denizens of the otherworld.

2

The Bonny Moorhen Pub, Stanhope

The Bonny Moorhen Pub is a wonderful alehouse built in the 1700s in the historic village of Stanhope, in Bishop Auckland. Known as 'the forgotten dale', or the historic capital of Weardale, Stanhope is steeped with history and legend. Indeed, back in 1818 the infamous 'Battle of Stanhope' took place when the local miners took on the Prince Bishop of Durham after he decided that taking food from the land (the Moorhen, amongst other game birds and food) was wrong. The locals thought otherwise, especially when times were hard, and refused to cease their hunting.

In defiance of the Prince Bishop, he rounded up his army and set off to teach the Stanhope folk a lesson they would never forget. He apprehended a number of the 'poaching ringleaders' and imprisoned them in the cellars of an inn (now the Bonny Moorhen). When the lead miners heard about this they rallied together in anger and set off to do battle with the Bishop's men. Outside the inn the miners demanded the release of their comrades but the Bishop refused and a skirmish broke out between the two sides. This led to a full-blown, bloody and riotous battle resulting in many, many serious injuries – but no deaths – to those on both sides.

Standing opposite the Bonny Moorhen on the other side of the road is Stanhope Castle, which is privately owned and adds much character to an already charismatic neighbourhood. It was between these two buildings where the actual battle took place.

An acquaintance of mine, Andy Local, and his colleague Craig Best had visited the pub on one afternoon out and, as it transpired, witnessed some odd paranormal activity. As they were chatting to the (then) pub owner, a photograph that was standing up and propped firmly behind the bar came hurtling across the counter and landed on a seat near to the bar window, which is a good 10 feet or so from its original position behind the bar. Taken aback by what they had just witnessed the owner said that 'this kind of stuff happened all the time'. After retrieving the photograph and placing it back behind the bar they then resumed chatting with the owner, only *now* they chatted about ghosts and the paranormal in general. Andy had discovered quite a bit in relation to this particular pub's alleged paranormal activity and had subsequently telephoned and informed me of it. I decided to act upon Andrew's information and made a visit to the pub in question. Upon visiting the pub to check out the ghost stories, I interviewed the landlord, Dave Shaftoe, upstairs in his flat. I asked Dave if he could tell me in his own words why he thought the pub was haunted.

'Well, for starters, when I am behind the bar alone glasses have been thrown at me. The glasses come from the counter down to my right and they have hit me on my leg

quite often; this has happened in front of customers too. The photograph often comes off the back of the bar, often when no one else is around but sometimes when people are around, and your colleagues can testify to that. Also when I am in the cellar I can feel things touching my head. The ghost has actually approached me too. One night – a couple of weeks ago – I was in the cellars when this figure came from nowhere and advanced toward me. The figure pointed at me and said "stop talking about me". He was a large aggressive kind of man and it really unnerved me.'

'So you are convinced that this placed is haunted then?' I asked him.

'Yes, without question,' he told me.

'So, what do you know regarding the history of the building?' I asked Dave.

'Well, it was built in the 1700s and originally called the Black Bull. Then it burned down in the early 1800s – not sure exactly when – but when it was rebuilt it was renamed the Phoenix, as it was said to have risen from the flames. I had heard it was renamed the Bonny Moorhen after the fighting men of the battle of Stanhope and I do know there are two tunnels connected to the building. They were built for the bishops to escape from during the reformation. The place has always been a public house and the cellars were once used for incarceration.'

A short but nevertheless interesting interview; he had mentioned during our chat that if I needed to find out more, I should ask his wife; so I did. I asked her if she'd had any experiences followed by the killer question – are you sceptical?

'No, I am definitely not a sceptic, definitely not. I know there is something in here but I tend to try to and not let it rule me so to speak. So, as long as they don't hurt me and mine, then I am happy with how things are.'

'So how do you feel when it throws glasses at Dave? Do you get disturbed by that?' I asked.

'Not really disturbed because although it is quite scary, it does feel as though it is just playing. Other times when he is downstairs alone I worry, as on one occasion after he came upstairs to the flat he seemed quite agitated. When I asked him what was wrong he said, "I have been in the cellar and I have been talking to a man." When he got into bed our bedroom door opened on its own and I thought it might have been the wind although no windows were open at that time. Dave told me that "it was the man from the cellar, he had come upstairs". We then noticed after we had closed the bedroom door that it reopened. This happened again and again, every time we closed it. This went on for an hour or so until we both fell asleep.'

After gaining the relevant permission I spent some time at the pub through the night and documented very little in the way of objective paranormal activity. There were, however, one or two minor occurrences that are worth mentioning although it is not hard evidence of anything paranormal – not by a long chalk! During our group's first vigil in the main bar area, a number of EMF readings showed up on the electromagnetic field meter although no reading was determined earlier on in our baselines. No one knew where this EMF emission came from so if the theories are correct and spirits do indeed draw their energy from natural flowing electromagnetic fields, then who knows, maybe a spirit presence was trying to make itself known. Whatever the cause we do know that there was indeed some minor anomaly within the natural EMF; however, nothing to which we could hang our metaphorical hat.

The other oddity occurred when I, and a number of other investigators, felt a cold breeze rushing through the bar area. Attempts to explain it were quickly ruled out, again due to the earlier baseline tests. No draughts were detected and the doors were closed during this experience. It must be noted that another draught was recorded in a séance that was held in the bar area at the close of the investigation, and these breezes will remain – at least for the time being – unexplained. The Bonny Moorhen Public House is a fascinating place and is steeped in local history. It does indeed warrant further investigation and steps are being taken by the author to carry out further work on the premises although I have become aware quite recently that the landlord that I spoke to in regards to the ghostly activity, Dave Shaftoe, has subsequently moved on from the premises into pastures new. Did he simply fancy a change of environment? Or perhaps was there another reason for his departure from the Bonny Moorhen pub? We may never know.

3

Durham Castle, Durham City

One cannot write a book on the ghosts of County Durham without including the beautiful castle that dominates the entire area of the City of Durham. There is no other castle – in my humble opinion – that can be better placed than this spectacular Norman structure. The castle and its neighbouring cathedral complement each other so beautifully, standing on opposite ends of Palace Green. Both structures stand atop a steep, wooded embankment which is more or less encircled by the River Wear, making the castle and its magnificent counterpart almost untouchable during our once-troubled times. It was a formidable location for defence during the civil and border wars, and because of its supreme location it was easily able to withstand many a battle and siege. The Scottish Kings Malcolm III and Duncan III, along with many others, proved this by attempting to take Durham Castle, but in the vast majority of cases it was a complete waste of time and resources. Usually, attempts like this ended in total failures.

A few years after the Norman Conquest of 1066, and by order of King William, the castle at Durham was built and is a superb example of the early motte-and-bailey style of construction that the Normans so often favoured. The Bishop of Durham was given royal authority on the Kings behalf and subsequently the castle became the Bishop's seat. Until they found a more suitable accommodation for the Bishop's seat, it remained at Durham Castle, which was known as the Bishops Palace. Eventually, the Bishop's seat found its way to Bishop Auckland whereupon *c.* 1840 the castle found new use as a college. Now a well-renowned university, this former castle is one of *the* most impressive institutions for higher education that the United Kingdom has to offer its young and forever growing number of students and scholars. Antony Bek, the Prince Bishop of Durham during the early fourteenth century, created its magnificent Great Hall which really is a sight to behold. This outstanding room was known as the longest great hall in Britain until the fifteenth century, whereupon it was 'downsized' by one Richard Foxe (1448–1528). The hall is decorated with lots of military ephemerae including artefacts, *objet d'art* and items from the English Civil War and the Napoleonic Wars. Portraits of the past bishops and university dons adorn the enormous walls with the lower half of them being covered in a fine-looking oak wood panelling.

In regards to the ghosts here at Durham Castle/University, well … there are a few. The most famous of these spectres is said to reside on an ancient wooden stairwell known as the Black Staircase. Located betwixt the Great Hall and Bishop Pudsey's building this dark wooden structure – hence the name, 'Black Staircase' – was built *c.* 1662 and reaches an impressive 60 feet in height. This one-time freestanding flight

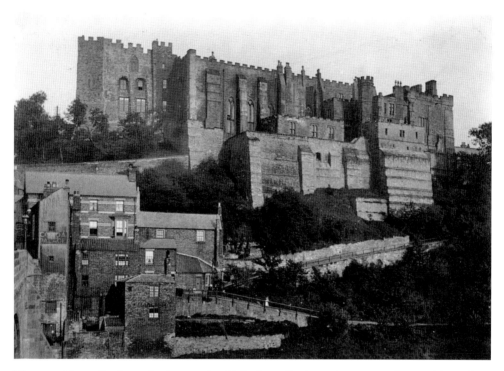

The magnificent Durham Castle towering high above Durham city *c.* 1900, haunted by a ghost known as the Grey Lady. Thought to be the wife of a former Bishop of Durham, this sad spectre is said to walk the castle's 'Black Staircase' after committing suicide there many years ago. (*Picture courtesy of Newcastle Libraries and Information Service*)

of steps is now supported by a number of circular columns, but this was not always the case. In its early days it was supported by nothing but the walls. If you ever get a chance to see this stairwell for yourself I would recommend you do so, for it is magnificent.

The ghost that walks the stairwell is known to everyone as the Grey Lady of Durham Castle and she is a well-known element of the castles history, and indeed its very fabric. The ghost is thought to date back to the sixteenth century and is said to be the wife of one of the former Bishops that once resided there. After feeling depressed and suicidal – and for reasons unbeknown to anyone – she one day decided that she was going to end her life. She ascended the Black Staircase, whereupon she subsequently hurled herself from the top. Over the bannister she went, and fell the full, terrifying 60 feet through the small gap to her imminent death. Visitors and staff alike have reported seeing the sad ghost of the Grey Lady every now and again as they make their way back and forth, up and down the Black Staircase. More often than not, her spectre is seen throughout the hours of darkness. It is said that on some occasions, her essence is not so much seen but more often felt leaving a spine-chilling shudder with those that encounter her. Back in 1987, a ghost hunter going by the name of Brian Smith had prepared to spend a night on the castle stairwell – alone – hoping to catch a glimpse of this infamous spectre, but his all-night vigil was sadly cancelled due to resident students. It was *thought* that they may have attempted to drum up false phenomena as a joke during his investigation.

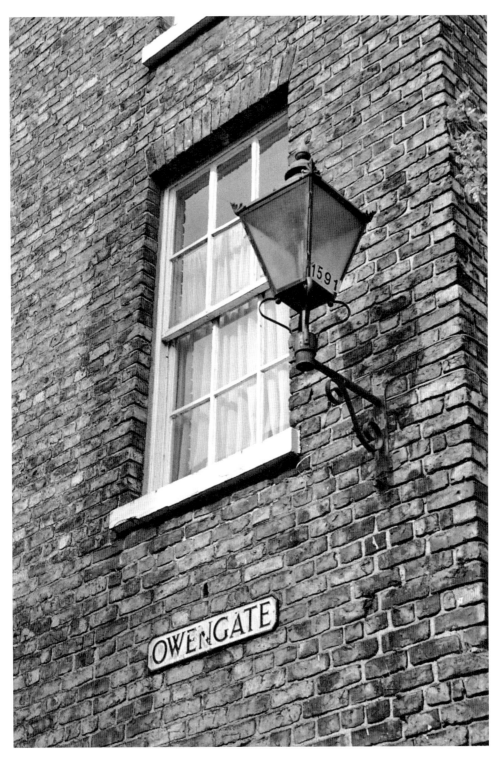

Owengate: this area is haunted by the ghost of a former university professor who killed himself at the castle.

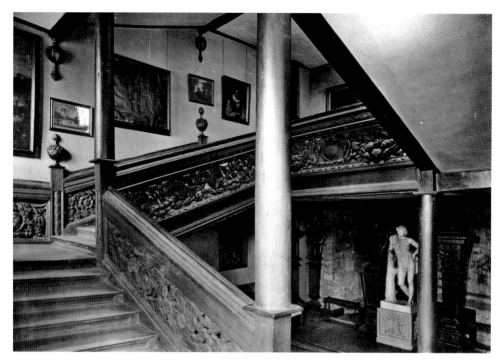

The Black Staircase of Durham Castle. (*Picture courtesy of Newcastle Libraries and Information Service*)

To my knowledge his vigil was subsequently rescheduled for later in the year when the students were 'not in residence'. At present, I am unaware if Brian's vigil did take place and efforts to find out proved fruitless. It would be interesting to know if he managed to carry out this investigation, and more interesting to find out if he actually caught a glimpse of the phantom. If Brian or someone that knows him is reading this book, then perhaps they could ask him to get in touch with me to let me know how he got on.

I am not sure what it is with individuals throwing themselves down stairwells at Durham Castle but it seems to be a growing trend for its former inhabitants. A former University Professor is thought to have thrown himself down a steep flight of stone stairs and his ghost is said to haunt the Owengate area of the castle complex. Whatever you make of the stories of the alleged ghosts of Durham Castle, it matters not. You may choose to believe that these ghosts still walk here many hundreds of years after their deaths, or you may not; you are perfectly within your rights. But one thing is certain: their eerie presences have most certainly been felt by some, leaving me in no doubt that Durham Castle is one of the most captivating, and prevalent places of ghostlore in County Durham.

4

The Dunn Cow Pub, Witton Le Wear

The Dun Cow was constructed around 1799, and thus has had time to build up a decent collection of ghosts over the centuries, although sightings by managers and recent staff seem to be thin on the ground. However, my colleague Mike Hallowell and I were once assured by some locals and former staff members that a spectre does indeed haunt this charming little inn.

The spectre, we were told, is said to be that of a former landlord who makes his presence felt by moving the bar accoutrements about, and generally making a nuisance of himself in a poltergeist-like fashion. The author prefers to use the term 'poltergeist-like', as the ghost at the Dun Cow is certainly not a true poltergeist. Rather, it is a playful and interactive spirit. Believe me when I say there is a difference!

Mike and I also managed to ascertain that in times past a number of customers were most reluctant to occupy or pass through a certain passageway inside this old boozer, for it is there that the ghostly landlord apparently likes to pace back and forth. Unfortunately, and quite typically, he failed to make an appearance during our visit.

5

The Phantom of Crook Hall, Durham City

Crook Hall is by far one of my favourite 'haunted locales' in the county of Durham and I never get tired of visiting its wonderful old buildings and beautiful surrounding gardens. I remember the last time I was there when researching ghosts of Durham city; I was given an unforgettable tour of the building and its gardens by owners Keith and Maggie Bell. Their hospitality towards me on that day was exemplary and for this I thank them enormously. Oddly, during my visit that day, I experienced what I would describe as 'an unexplainable event' while looking around in the Jacobean section of the house. Before we go further into the history and resident ghosts of Crook Hall let me explain just what happened to me during my visit.

On the top floor there is a large room open to the public and in this room there is a lavatory. I had decided that I needed to pay a visit so I made my way into the small room and locked the door behind me. Soon I became aware of somebody entering the main room. By this I mean I clearly heard the clump-clumping of heavy shoes across the wooden floor. The footfalls made their way from the room's entrance (which is on the same side of the room as the lavatory) across the floor to the window at the opposite end of the room; this is where the footfalls stopped. The footfalls began rather loudly and seemed to fade a little as they reached the window at the far side of the room – as you would expect if someone was walking *away* from you. I simply assumed that a visitor to the hall had walked into the room and was now standing looking out the window, which incidentally gives you great views of Durham Cathedral in the distance. Expecting to see someone when I came out of the lavatory I was bewildered to find I was the only person in the room.

Having the paranormal on my mind I quickly looked around to see if anyone was in the area and found that I was the only person in this particular section of the house at that time. I even yelled out, 'Is anyone there?' but received no reply. Further, I then realised that I had only heard the footfalls as they made their way *to* the window in the room, and not *back* over on a return journey to the door. The thought occured that someone – perhaps a resident spectre of crook hall – had come in the room while I was in the little boy's room and walked to the window at the far end of the room whereupon the psychic activity ceased, hence the lack of footfalls making their way back across the room. This is how it came across to me and it is the only explanation I can come up with. One wonders what I would have seen if I had looked out of the door as the footfalls were pacing across the room. Would I have seen a ghost? Would I have seen no one but still heard the footfalls? Perhaps the footsteps would have ceased immediately as I opened the door? I will never know. What I do know, however, is that I heard ghostly footsteps on my visit there that day.

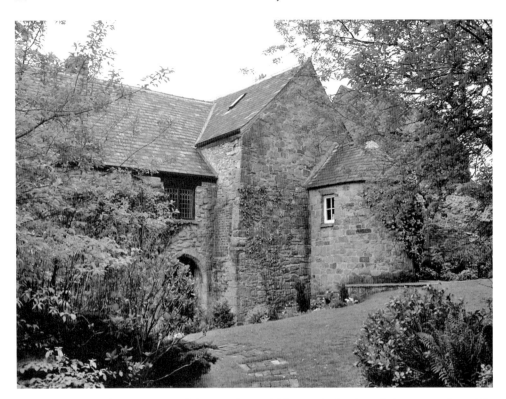

Crook Hall in Durham city; one of the most beautiful houses in Durham. It is open to the public and lays claim to a White Lady ghost.

Crook Hall itself can be found a short distance north of the centre of Durham city and stands in what I can only describe as a grandiose environment. The thirteenth-century hall affords a spectacular setting to its remarkable grounds and it is a place of tranquillity and tremendous splendour. Named after Peter Croke, who possessed the home in the early fourteenth century, it is now the family home to Keith and Maggie Bell. They insist that their beautifully nurtured gardens and old historic home must be accessible to the community so that each and every person that chooses to visit can experience its intrinsic allure and sheer magnificence. The building is like none other I have seen, in the respect that it has three sections that all date from different time periods. There is a Grade I listed medieval hall which was built around 1208. The hall, with its tall walls of stone and high roof, provides Crook Hall with a magnificent taste of medieval life. Then we have the Jacobean manor house, which was built in 1671, complete with a wonderful circular turret. If that doesn't impress – which it should – there is the grand Georgian House. It is three levels high and covered with beautiful ivy; this portion of the residence was constructed by the Henry Hopper of the Hopper family of Shincliffe when they acquired the land and buildings in 1736.

The ghost tales at Crook Hall are fascinating and during my visit they were discussed in some detail. The most well-known Crook Hall ghost – I was told – haunted a number of areas within the confines of the premises and although she has been seen on a few occasions, she is more often 'sensed'. The ghost is known as the White Lady, and is

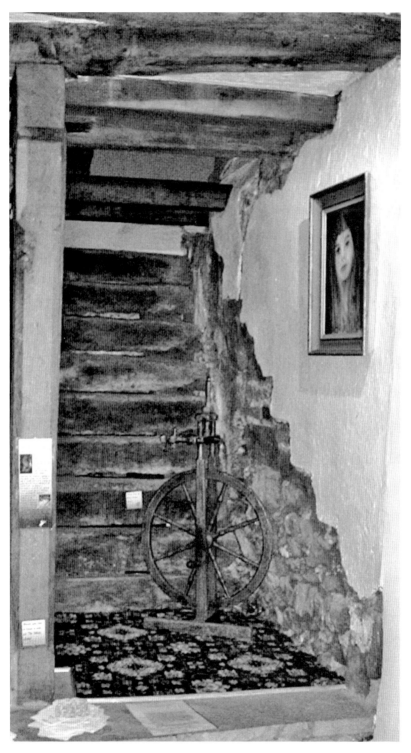

The haunted stairwell in Crook Hall. It is here on St Thomas's Eve (20 December) that the ghost lady is said to be seen as she floats down the stairwell wearing an elegant white gown.

Crook Hall viewed from the lane. It was on the top floor of the nearest building where the author had his strange encounter with the paranormal.

thought to be the niece of the one-time owner of Crook Hall, Cuthbert Billingham, who had the property around 400 years ago. One of the best times to see her by all accounts is said to be on 20 December – St Thomas's Eve – where she has been seen to float silently down an unused ancient wooden stairwell that is housed in the circular turret of the Jacobean part of the manor house. Her most famous sighting, however, happened a few years ago now, with the details of it being written down and placed on a wall in the house for visitors to see and read. Owner Keith Bell showed me where this framed account hung in the house and I proceeded to read it with great interest. I asked, 'If I ever wrote about Crook Hall, could I reproduce the account verbatim in my books?' I was told that I was 'more than welcome to do so'. So here it is. It reads:

These ancient stairs, perhaps the oldest in County Durham, are haunted by the White Lady. She was the Niece of Cuthbert Billingham, who inherited Crook Hall in 1615. He quarrelled with the citizens of Durham and in his rage, cut off their water supply. There have been numerous sightings of The White Lady over the centuries. She is usually said to glide silently and gently down the stairs, although on one occasion, she was reported to thoroughly alarm guests who had been invited to Crook Hall for a ball by a rather more dramatic appearance. A banquet had been laid out in the medieval hall, but as the guests moved into the Screen's Passage, they heard a soft rustle followed by a loud crash. When they looked into the hall they found that the tables had been overturned, destroying the banquet. A further rustle and a glimpse of a white figure convinced them that this was the work of the White lady.

The Grange, Hurworth-on-Tees, Darlington

The Grange at Hurworth is a magnificent edifice located in Hurworth-on-Tees on the County Durham and North Yorkshire borders and was once a beautiful Victorian mansion that was lived in by the Backhouse family. By 1875 the building work was complete and it is believed that it is built near the spot of Hurworth cottage. The Grange was built as a wedding present for the nephew of Alfred Backhouse, James Edward Backhouse, when he married Elizabeth Barclay Fowler in 1873. They had fourteen children and when James died in October 1897, he left the house to his eldest son Edward.

In or around 1912 – no one knows for sure – the occupation of the Backhouse family ended and, as far as local records show, between 1912 and the 1950s the house was occupied by two more families, the Rogerson family and the Spielman family. In 1955 the Grange was once again 'up for sale' and subsequently acquired by the Revd William Donnegan and the Hospitaller order of Saint John of God. The Holy family school of Saint John of God, which was nearby, was relocated into the Grange and from that point on the Grange was used as a school for boys for those wishing to become Hospitaller brothers. Back in 1967, the Brothers decided to sell the Grange and close down the school, giving Durham County Council the opportunity to purchase it in 1968. They, in turn, gave the property to the Hurworth church parish council and, on 20 September 1969, they opened this former beautiful stately home as a community centre, which is still being used today by the locals and the community of Hurworth-on-Tees.

Over the years the Grange has reputedly been subjected to paranormal activity and alleged ghosts are often seen wandering aimlessly along the corridors before suddenly disappearing into the ether. Doors are said to open and close on their own, and often cold spots and unexplained temperature drops have been reported. On one occasion a voice was heard coming from the upper section of the building but upon inspection no one was found. Another occasion two burly builders were working in the cellars when they had a terrifying experience. They downed tools and left, never to return. The Grange has a White Lady that walks the premises too. She is believed to be the ghost of one of the Backhouse family daughters (as her attire seems to indicate) but no one is sure. She has been seen on the main stairwell as well as in other parts of the old house. Many chilling 'Electronic Voice Phenomena' (EVP) have also been picked up there, including a disturbing recording that simply says, '*Get out … this is my house.*'

Colin and Cindy Nunn own a research team called Anomalous Phenomena Investigations (API) and are very good friends of mine. Before moving back to

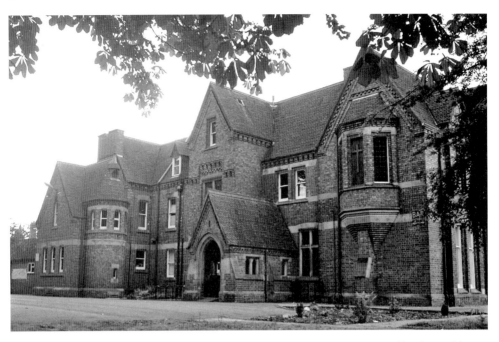

The Grange in Hurworth-on-Tees. An old Victorian mansion house once owned by the Backhouse family. It appears some of them may still reside within.

The cellar area underneath the Grange; this was where one of the many chilling anomalous sound recordings were made.

The stairwell that the ghost of Hurworth Grange walks. An eerie photograph was taken in this very spot of a pair of phantom legs.

California in the USA – where Cindy originally came from – they had been methodically investigating the Grange and built up a fantastic array of evidence and historical data to support the notion that it *is* haunted. To my knowledge there was no other team in our region (or even in the UK) at that time, to conduct such a lengthy survey on this scale and the API team must be commended for this. Their hard work and effort paid off when the BBC produced a film detailing their investigations and findings from this magnificent building and one-time abode.

A certain photograph is also in existence which was taken by Colin Nunn. It shows a rather peculiar anomaly on the main stairwell. A series of photographs were taken during one of the API's many overnight investigations and, in total, about 100 pictures were taken in succession. All the pictures were taken with a technique known as 'cable release' or 'time exposure'. In short, each frame (in this particular instance) took about fifteen seconds to take rather than the usual instantaneous 'click'. Time exposure on certain cameras enables the photographer to take pictures in the dark without using the flash mechanism (massively reducing the chances of light reflections from flashguns, which will produce light anomalies) as long as the timed exposure is correct. Night-time shots in cities with lights and reflections upon the rivers etc. are taken this way (I use a five-second exposure on F8, which normally brings good results). If the diaphragm in the camera is left open *too long*, the light floods in and the picture will be over-exposed; if it is not left open *long enough*, the picture of course will be under-exposed.

On one of Colin's images there is what looks to be a pair of legs on the stairwell. The legs are cut off at the thighs but this is due to the photo framing. It must be pointed out that this is not just a photo of disembodied legs. Had the camera been tilted further up, or situated further back, perhaps more of the 'ghost' would have been in the frame. Of course, I am not taking anything away from Colin's picture – it is indeed rather impressive – but merely specifying *why* there are only legs in the frame, and on the negative.

That aside, the fact remains the Cindy and Colin Nunn have amassed a wealth of good quality evidence to suggest the Grange is indeed haunted. I have spent the night there myself on about five occasions and found the place to be truly chilling to say the least.

Harperley POW Camp, Crook

The former prison camp at Harperley was built by the Italian prisoners that were held there in the early 1940s. They built the prefabricated huts that stand today and it was these huts that went on to house the German prisoners of war. In comparison to most POW camps, this camp at Harperley was known for the hospitality, kindness and the well-being of all the prisoners that were held captive during these times. Although they were worked extremely hard, these prisoners were treated with respect, fed well and looked after. They were also allowed to indulge in pastimes such as gardening and painting, and some of their original works of art can still be seen today hanging up in some of the huts.

Out of the sixty huts that originally occupied this site, fifty now remain and a number of them have been restored. The rest are awaiting restoration. There is also a chapel and theatre with a built-in orchestra pit, and this was used by the prisoners for putting on shows and entertainment. This theatre was also used as a cinema. Harperley camp was once open to the public as a museum where people could visit the camp, step back in time and be presented with the Second World War POW camp experience. This POW camp was classed as an ancient monument by English Heritage a few years back now, and in 2009 it was featured on the BBC as part of the *Restoration* programme. After running out of money, the POW camp owners, James and Lisa McLeod, put it up for sale on eBay for £900,000 but amazingly it received no bids whatsoever. Every cloud has its silver lining so they say, and this silver lining came in the form of English Heritage when they recently offered to restore the camp at a cost of £500,000, whereupon it is hoped it will become the amazing tourist attraction that it was always meant to be.

The ghost of Harperly is a man who has been seen on the road close to where the visitor centre is, and opposite hut thirteen. I should know as I was the one that saw him on the night of 30 July 2005. I was invited up to investigate the property with the aforementioned research team, Anomalous Phenomena Investigations (API). The sighting occurred whilst I was on a break in-between the night vigils and it occurred when I least expected it. At 12.30 a.m., while standing outside of hut thirteen, I was chatting to colleagues when I suddenly became aware of a figure out of the corner of my eye. At first, I thought it was just another investigator, but when I turned to take a look, I realised it was not. This figure, which I am adamant was male, moved forwards and walked straight into the back of a tractor that was parked there. Then it simply vanished before my eyes.

It all happened in a few seconds and the sighting was over before I even knew it. This is usually the case. Unfortunately, my colleagues were too slow to catch a glimpse of this

Harperley Prisoner of War Camp near Crook, classed as an ancient monument by English Heritage and the scene of a bewildering ghost sighting.

figure, and therefore they never saw it. However, because they never saw it, I therefore *must* have lied about the whole thing, or misinterpreted what actually happened. I read somewhere once in a paragraph relating to my sighting that 'it was raining that night' so therefore 'that accounts for the sighting'. It was suggested that the rain somehow played a trick on my eyes and forced me to see what I did! Debunked, I think not. It obviously hasn't occurred to some folk that ghosts – whatever they are – may actually exist … and that I, not them I hasten to add, saw one on that night.

8

High Force, Teesdale

The magnificent waterfall known as High Force is one of the most spectacular waterfalls in the entire country, located in the north-east of England. From its source at the top of the North Pennines, the River Tees oozes, snakes and makes its way through the exuberant countryside and parkland, slowly gathering momentum as it goes. The softened rumbling of the river suddenly turns into a deafening, thunderous roar as the river drops nearly 25 metres into the plunge pool below. High Force is a waterfall that you *must* respect; if you don't it will surely kill you. Visiting the waterfall you must take great care and never underestimate is power. Children must always be supervised.

Legend has it that the ghost of a hawk flies in and around the skies near High Force. It is said that the hawk was once witness to a brutal murder that occurred there hundreds of years ago, whereupon the victim had his head smashed in with a rock before being thrown over the waterfall. The hawk, known as the High Force Hawk, is said to keep watch over the area, making sure no one else succumbs to the same grisly end that the unfortunate individual did all those years ago.

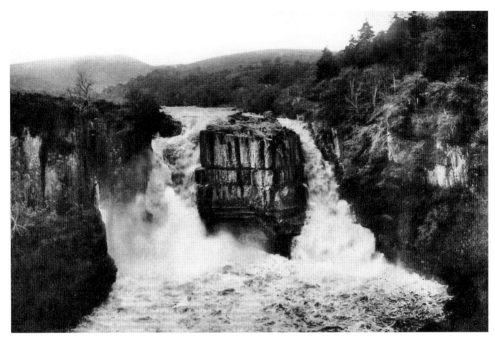

High Force in Teesdale, the most magnificent waterfall in the North; in this image the water is in spate. The area is said by some to be haunted by a phantom hawk that glides around the falls before disappearing into thin air. (*Picture courtesy of Newcastle Libraries and Information Service*)

An image of a hawk in flight; this image depicts the phantom hawk of High Force.

9

Jimmy Allen's Pub, Durham City

Jimmy Allen's is tucked away under Elvet Bridge in Durham city centre and is a modern pub that could, more or less, be classed as a wine bar. Jimmy Allen's has a number of floors, the top one actually coming out onto Elvet Bridge itself. Having visited the pub on a number of occasions, the author came to the conclusion that although there *is* indeed a certain 'atmosphere' within its walls, it is not your stereotypical haunted inn. That's not to say I don't think it is haunted – on the contrary, I do.

On the lower level of the premises the phantom of the legendary 'Jimmy Allen' is said to reside. Jimmy was the official Northumbrian piper to the Duchess of Northumberland and for crimes such as hustling and theft he spent the last seven years of his life locked up in a cell there. The premises that is now Jimmy Allen's you see, once housed the old Durham Prison.

Initially Jimmy was sentenced to death for his crimes, but his sentence was later reduced to life imprisonment by the Prince Regent. However, fate would deal him a vicious blow, for his sentence was only commuted the day *after* he was executed in 1810. It is said that if you listen carefully you can hear the ghost of Jimmy Allen playing his Northumbrian pipes, the melodic sounds reverberating around the old lower levels of this one-time gaol house.

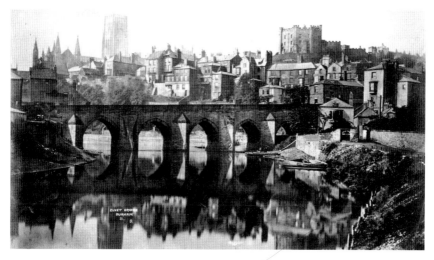

A view of Durham city and Elvet Bridge *c.* 1890. Jimmy Allen's public house is tucked away under the building that is situated on the far right of the bridge. (*Picture courtesy of Newcastle Libraries and Information Service*)

10

Lumley Castle, Chester-le-Street

Lumley Castle is a Grade I listed building that is owned by the Earl of Scarborough. It stands majestically on a large hillock just off the A1 Motorway overlooking the County Durham town of Chester-le-Street. Many a time I have driven past this fourteenth-century edifice during my travels and its sheer awe and aesthetic beauty never fails to take my breath away. It was originally built as a manor house by Sir Ralph Lumley, but was later converted into a castle in 1389 after Lumley had returned from his battles over the border in Scotland. Ralph was later imprisoned and then executed after being caught up in the plot to overthrow Henry IV, therefore his estates fell into the hands of the [then] Earl of Somerset. However, by the early 1420s the castle and its lands were back in the possession of the Lumley family after Ralph Lumley's grandson Thomas, came to own it.

By the nineteenth century the castle was the official residence of the Bishop of Durham, and not long after it became a students' hall of residence for University College, Durham. In the 1960s it was sold by University College and by the mid-1970s it was converted into the fifty-nine-bedroom hotel it is now. Its management was subsequently handed over to 'No Ordinary Hotels' although it is still actually owned by the Earl of Scarborough.

I have been to Lumley Castle on many occasions and every time I visit I can't help but be blown away by its wondrous, ambient feel. The castle simply oozes a charm and character like no other. I spent the night there after my brother's wedding and thoroughly enjoyed meandering around the creepy corridors at night and generally soaking up the atmosphere of this well and truly haunted castle. It looks magnificent at night when it is illuminated by its massive floodlights, and sends an eerie chill down my spine. Thinking about it to this day still makes me shudder in amazement.

Another night I spent there was when I attended one of their famous 'Elizabethan banquets' with an Aikido club that I once belonged to. I remember being sat in the great hall singing 'olde worlde' songs, while feasting on soup, meat and bread before washing it all down with fine ale and Lindisfarne Mead. Attendants in period costumes were on hand to serve the 'feasters' and refill their empty glasses while the sound of harps and fiddles reverberated around the great hall, adding to the already ambient atmosphere. After an evening in the haunted 'Dungeon Bar' downing many more a fine pint, I made my way home feeling full to the brim, and rather pleasantly intoxicated to say the least … Ah, memories.

There is, however, a more sinister side to this castle in the form of its resident ghosts. The castle has reputedly been haunted for many years now, with spectral inhabitants

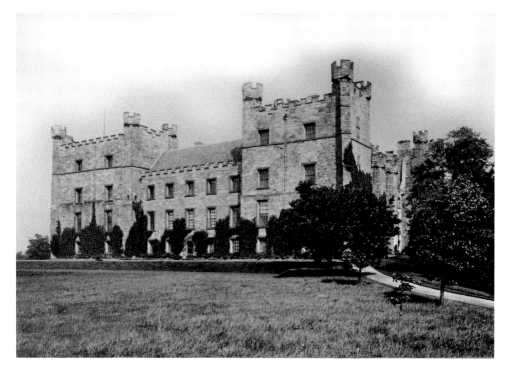

Lumley Castle in Chester-le-Street *c.*1910. This Grade I listed building is owned by the Earl of Scarborough and has a plethora of ghosts including phantom monks and a spectral woman known as Lily of Lumley. (*Picture courtesy of Newcastle Libraries and Information Service*)

forever pacing its ancient corridors, rooms and dungeons. Persistent rumours of poltergeist-like activity such as the moving of furniture and the slamming of doors keep coming in, along with unexplained footfalls being heard along empty corridors. The Australian Cricket team know this only too well after they stayed there for a few nights back in 2005. One player decided to gatecrash his team mate's room, after an unnerving incident, as he was too frightened to stay in his own. Newspapers and the media in general lapped up the story and it was printed in almost every north-eastern tabloid. Going back further, to 2000, a few members of the West Indian Cricket team actually checked out of the hotel after experiencing terrifying paranormal activity. It seems the hotel's phantoms don't really like cricketers!

Back in 1996, the aforementioned ghost hunter Brian Smith (see the Durham Castle section) and his friends, Tony Murphy and Malcolm Wakefield, were allowed to stay overnight in the dungeon bar in search of Lumley's most infamous spectre, Lady Lily of Lumley, who was Sir Ralph's wife. Lady Lily was a former Catholic said to have met her untimely demise at the hands of two priests (or monks) well over 600 years ago. After joining the Lollards – a political and religious movement from the fourteenth century – the priests called in at the castle and beseeched Lily to reconsider her faith; but for her own reasons, she ignored their requests as she had no designs whatsoever to return to Catholicism.

Action had to be taken, so the priests – who were based at Finchale Priory – accosted and imprisoned her in a small bedroom within the castle walls. It was then decided that death could be her only sentence, so she was brutally killed within the bedroom and then her body was mercilessly dumped from a great height down into the stone well. Her remains were said to have been found many years later when the well was eventually opened up. Another version of the tale suggests that she was viciously assaulted before being thrown down the oubliette into the castle dungeons where she was left to die in agony. This stone dungeon is now home to the main bar and it was here that Brian and his friends spent the whole night.

Pathetic moans and groans have been heard coming from the dungeon bar area by visitors and staff alike when they know that no one else is in there. Some say you can feel Lily as she rushes past you on the steep stairwell that now leads to the great hall from the dungeon bar. The patter of bare feet can also be heard as they make their way across the cold stone floor, and an eerie sense of presence is often felt by bar staff and hotel guests. I am not sure what Brian Smith and his friends may have seen on his vigil, but if these reports are true, they may have had a very interesting night indeed. Lily is also said to frequent other areas of the castle too. It is said that every night, she rises from the bottom of the well and stalks the castle until the early hours. If you ever stay over at Lumley Castle, then do listen out for footsteps in the dead of night; if you are lucky enough to hear them outside your room, be sure to quickly to pop your head out the door; you never know, you might be lucky enough to see her!

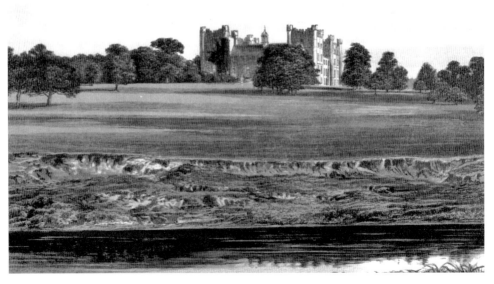

A drawing of Lumley Castle from the west showing just how large the Lumley estate is. (*Picture courtesy of Newcastle Libraries and Information Service*)

An artist's representation of the phantom monks that are said to walk the grounds of Lumley Castle. (*Picture courtesy of Drew Bartley*)

It is also believed that a number of monk-like figures haunt the grounds of the castle and have been seen by people as they make their way around the grounds. It is suggested that Lily's husband came back from Scotland, heard what had happened to his wife and so sought revenge by bringing the priests back to Lumley and despatching them in a bloody and brutal way.

The Garden House Pub, Durham City

The Garden House pub is located on North Road, leading into Durham city centre. The inn is a well-known landmark, and is as much a focal point to the area as its neighbouring church. It is a traditional olde worlde style public house that was built around the early 1700s and formerly known as the 'Woodman Inn'. This fine drinking hole became known as the Garden House Hotel in the latter part of the nineteenth century and has six *en suite* bedrooms on the upper level of the premises adding much character and charm to the building. Selling fine wines, real ales, good lagers and traditional pub grub, the Garden House Hotel really is as good as it gets. The fact that it is reputed to house a ghost or two makes the inn well worth visiting and of course it is why it features within these pages.

Paul Mash, owner of the pub, spoke to me during a number of visits to the inn and told me about the alleged spectres that reside there, along with some of the activity that his staff had experienced while working at this old boozer.

'Different things have gone on with different members of staff,' he said. 'They notice odd occurrences which all differ from the rest. We have a certain guest room upstairs where one member of staff experienced something quite disturbing. In fact it was so disturbing that she has never even spoken to us about it. She came downstairs ashen-faced and refused to tell us what had happened. Whatever it was, we think it must have scared her half to death. On a past occasion, prior to this incident, she explained to me that she had ventured into the room to clean it, and saw an indentation on one of the beds as though someone was actually sitting on it although no one could be seen. She knows the room is haunted. Personally, for me though, I feel the place has nice warmth to it and the alleged ghosts do not worry me in the least.'

The ghost of a young girl is reported to haunt the main bar area downstairs too, although details of this spectral inhabitant are scant, I was told that she has been seen wearing old-fashioned clothes. Not much to go on there then…

The old entrance to the pub, which is now used as a storeroom, has a 'certain feel' to it according to the resident chef, Steve Clough. He commented upon the fact that he, for some reason, does not like the original entrance to the bar and felt that there was indeed something – although he can't say what – residing down in that area. This was an area a where a fellow investigator and I actually heard an anomalous groan. A strange recording was also made in this particular area of a 'coughing noise'.

So, is the pub haunted? Well, it seems there have been a few occasions where the staff and owners have become convinced that it is and, given its history and its age, it's very likely to house a spectre of two from bygone days. It's hard to say with any certainty that the pub is or isn't haunted until further documented bona fide reports of ghost sightings come in, or further tests are carried out.

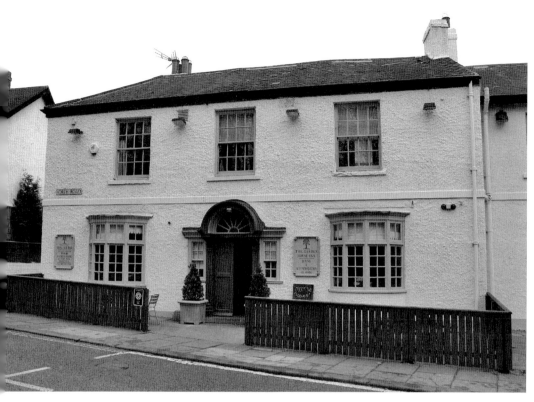

The Garden House pub on North Road in Durham city. The author spent the night here looking for ghosts but ended up finding a lot more than he bargained for.

Beamish Hall, Urpeth

Beamish Hall started off its life as a wonderful seventeenth-century country house. It is now a thirty-six-bedroom hotel surrounded by almost 30 acres of lush countryside, parkland and forest. Located 12 miles north-west of Durham City and 8 miles from Newcastle upon Tyne, this one-time abode of Robert 'Bobby' Shafto provides a wonderful location for weddings, parties, conferences and holidaying in general.

Its history is long and varied and can be traced back to the Norman Conquest. The hall, over the years has been home to many generations of influential families and this reflects in some of the location names within the hotel itself. For example, the Môn Boucher suite is named after the original family that resided there. The last Môn Boucher is said to have died in the early 1400s after five generations of the family residing there.

There is the Eden Restaurant named after the Eden family that lived there in the 1700s, and there is the famous 'Shafto Hall' named after the Shafto family who resided there up until 1949. After Robert Shafto passed away the hall fell into disrepair until it was purchased and completely refurbished in 2000. Beamish Hall is said to trace back to the French phrase *Bew Mys* and is translated into the words 'beautiful mansion'. Those that have visited it will realise this is certainly a truism.

The ghosts at Beamish Hall vary. It is said that the spectre of a man dressed in Victorian attire has been seen on many occasions staring out of a window in the aforementioned Eden Hall. A woman that is reported to be 'lost and terribly sad' has been seen at yet another window in the hotel, this time in the bridal suite. No one knows who these spectral forms are but a few suggestions have come forth. One suggests the woman might have been the deserted fiancée of Bobby Shafto – who knows, she may well be. Other phenomena have been reported at the hall over the years: strange noises have been heard to come from the main hall when those that experience them are certain that they are on their own. Footfalls are the most common.

The ghosts have led to various research teams visiting and investigating the premises with some very interesting results to say the least. One research team spent the night there with not one, but *two* members of the group claiming to see an apparition for the duration of five minutes while near the Shafto Hall. Described as an 'outline standing by a wall', this figure seemed to be watching the investigators. A few days later, the same figure was said to have been caught on camera by some of the hotel staff. It sounds very intriguing to say the least and I don't doubt for a minute that they experienced something very odd indeed.

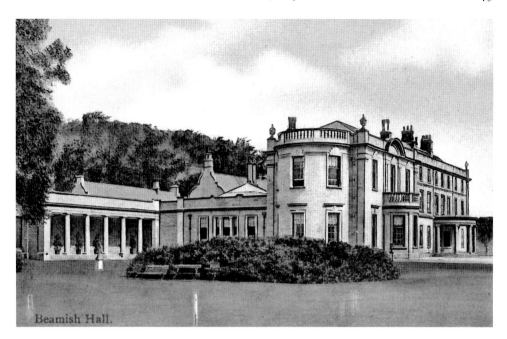

Beamish Hall.

A postcard image of the seventeenth-century house that is now Beamish Hall, the former home of 'Bonny Bobby Shaftoe' and the current abode for a number of spectres. (*Picture courtesy of Newcastle Libraries and Information Service*)

I remember carrying out an after-dinner speaking engagement at Beamish Hall with my good friend Mike Hallowell on a charity ghost-hunting night on Halloween 2006. We addressed over 150 charity ghost hunters on the phenomenon known as EVP (Electronic Voice Phenomenon), and our talk was entitled 'Voices of the Departed'. This was one of my early speaking engagements and it was received very well indeed with the questions and answers section lasting almost as long as our presentation did.

Supporters of the event were treated to an impressive beef dinner followed by a sticky toffee pudding to die for before the main events of the evening got underway. Events of this nature are not renowned for producing much proof of psychic or paranormal phenomena – one must remember that the main purpose of the evening was to raise funds for a children's hospice – but there were one or two peculiarities that deserve further examination.

In the State Room, Mike recorded a mysterious clicking sound that could not be heard normally by ear, so to speak, but was distinctly audible later when the recording was played back. The clicks were frequent yet sporadic and had no discernible rhythm. Later, when played back again during the debriefing, one lady said that the clicks were actually Morse code – and to be honest they certainly sounded like it. The participant said that the letters being repeated were CQD which stood for 'Come Quickly – Danger' and was apparently the historical precursor to the more popular SOS.

A couple of very odd photographs were captured too by various members of the public that were attending the investigation but in all honesty I felt these images were rather floored to say the least. Dozens of participants wandered freely around

the building after being told to stay in their respective groups, so to control any environments in a scientific sense was rather difficult, but we always knew this would be the case. The chap responsible for the actual night vigils disappeared into the woodland outside saying he was on a mission to find 'orbs' and was not seen again! Mike and I subsequently took control of the investigation and salvaged the night. Many of the first-time ghost hunters were then given the opportunity to experiment with ghost-hunting devices that I had brought along, such as EMF meters, thermometer guns, night-vision video cameras, motion sensors, EVP machines and much more.

After discussing the theories behind many ghost hunting methods and practices, and with much experimentation with them, the majority of the paying guests felt they had at least had their monies worth from the night and left with the knowledge that they had learned a little about ghost hunting and what it really entails.

That said, Beamish Hall really is a wondrous place to visit and I would recommend that one day you should pay the place a visit, along with the many other magical places featured in this book. You never know, you may just see a ghost.

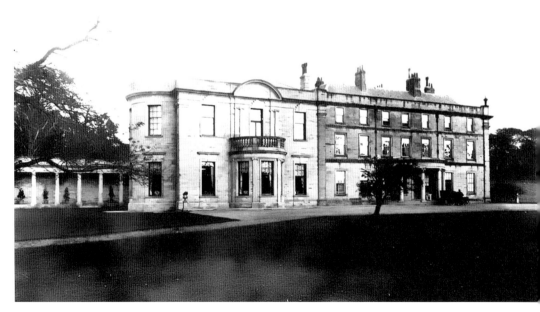

Another view of Beamish Hall dating from around 1900. (*Picture courtesy of Newcastle Libraries and Information Service*)

13

The Manor House, Ferryhill

The manor house in Ferryhill lies roughly 7 miles south of the city of Durham. In the sixteenth century, when first erected, the building served as a farmhouse. In 1642, John Wilkinson sold it to one John Shawe, and when Shawe died ownership passed to his grandson, Ralph. By the early 1700s, the house and surrounding land had been through a succession of owners. However, by 1885 only the house remained as the land had been sold on to a local colliery. In 1891 the building was fully renovated and subsequently occupied by a man called Henry Palmer. Since Palmer's death it has been rented and/or owned by many other occupants.

In 2001 a family bought the premises and turned the manor house into a thriving hotel, which is still open to this day. This sixteenth-century one-time orphanage, manor house and now hotel is reputedly haunted by a number of ghosts and spirits that once had some connection with the locality. The spectre of a woman is said to amble along the stairwell looking for her child. Those who have seen her claim that she looks as though she is deeply tormented. It is also said that the bones of several youngsters were found buried in the grounds adjacent to the house, leading some researchers to hint at the possibility of murder. Rooms No. 7 and 8 have also been subjected to extremely aggressive poltergeist-like activity and spectral apparitions have on occasion resulted in the present owners becoming quite literally terrified. Investigations there and two attempts at exorcism – which did not succeed – did nothing to curtail the strange phenomena in the residence. In fact, things became decidedly worse afterwards.

One night a few years ago, thanks to Fiona Vipond, I spent the night there and experienced fantastic paranormal phenomena. During a séance which I monitored, a trigger object – a lollipop – was quite literally taken from under my nose, removed from a flour tray that I had placed on the table in room 8. Not only that, the perfectly flat flour from which it was kept in was disturbed in such a way we had never seen before. It was as though someone had got three of their fingers and dragged them along in the flour creating a long, deep groove in the flour. They couldn't have, of course, because I was standing next to the flour tray at the time and had seen nothing!

Patches of flour were subsequently found all around the room and even in the next room too, which was the bathroom. Flour was also found near the door, outside the door, down the stairs and along the landing, indicating that whoever, or whatever, took the lollipop, vacated the room leaving this flour trail as it went. The others there on the night believed the culprits were spirit children that are said to reside in the premises, after all, during the séance they were told by Fiona to 'take the lollipop'. This we feel they certainly did as all present know for certain that no one else could have touched the trigger objects without being seen.

The manor house in Ferryhill; some of the most amazing paranormal phenomena that I have ever encountered occurred in room 8 at this ancient hotel.

A view of the manor house from its beautiful gardens.

Inset: Skulls and bones were reputedly found in the grounds of the manor house, leading folk to suspect foul play. Some say this is why the building is haunted. (*Picture courtesy of Julie Olley*)

14

The Manor House, West Auckland

From the manor house in Ferryhill to the manor house in West Auckland; this old edifice was originally built in the sixteenth century as a farmhouse atop foundations that date back to the twelfth century. For the next few centuries it served as a domestic dwelling for a number of people until in the early 1900s when it was converted by the Revd Thomas Lomax into an orphanage. After the orphanage the house once more became a private dwelling until its eventual conversion into a thriving hotel, which it remains to this day. It is even suggested that this Grade I listed building was at one time a hunting lodge to none other than King Henry VIII. It is thought he stayed on the premises during his visits to the north of England. Here, he would wine, dine, relax and of course take part in his hunting activities.

The Manor House Hotel is the archetypal 'manor house', steeped in so much wonderful history that – if you let it – viewing it from the exterior can almost take you back to the days of old. Stepping *inside* the hotel really is like walking into another world. It literally feels like you are moving back in time, with its oak-panelled walls, old-style period furniture, its stone fireplaces and its ancient anterooms. In my opinion old edifices like this are simply fantastic and I always relish visiting them wherever and whenever I get the chance. Crook Hall in Durham city – featured earlier in this book – for example, is another such building that is virtually alive in its respective history and subsequently grabs you – metaphorically speaking, of course – by the throat as you step inside; whisking you back to a time you have hitherto only read about or seen in movies.

But don't take my word for it; read the reviews. One claims that 'a warm welcome is extended to all its guests and you will enjoy a high standard of service and quality accommodation as you become acquainted with your surroundings. With secret passages and reports of ghostly sightings, this one-time manor house was home to the Eden family and (as we have just seen) the hunting lodge of Henry VIII'.

But it's the ghosts we are most interested in and by all accounts, there are a few. Over the years many odd happenings have been reported here and the hotel itself has no qualms in saying so. They offer ghost-hunting nights here and special Halloween parties with an old acquaintance of mine actually running quite a few of these investigations. Staff and visitors alike often report hearing strange footfalls and other unexplainable noises along the corridors and in the rooms, such as knocking and tapping, and even disembodied voices. Objects have been seen to relocate themselves as if being moved by unseen hands and, on occasion, terrified ghost hunters have been physically assaulted by unseen forces. There is another account of an assault that came from an individual

The manor house in Bishop Auckland; said to be the former hunting lodge of King Henry VIII this edifice has been subjected to some harrowing paranormal activity.

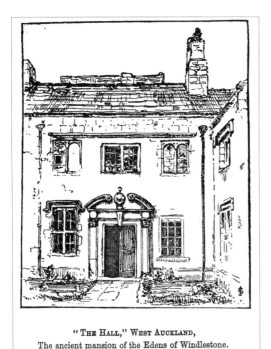

"THE HALL," WEST AUCKLAND,
The ancient mansion of the Edens of Windlestone.

A pencil drawing simply entitled, 'The Hall, West Auckland'. (*Picture courtesy of Newcastle Libraries and Information Service*)

claiming to have been grabbed by the throat by a phantom monk! This occurred in Room 34. In fact, not long after the release of my book, *Paranormal North East* (Amberley Publishing, 2009), I received an email from a Durham chap named Michael Carter who had read the book and felt that he had to tell me how much he enjoyed it. In his email he also happened to mention that he and his wife had stayed over at the Manor House Hotel in West Auckland, and his wife experienced something very odd during the course of the night. Michael takes up the tale;

> I had my wedding reception at the Manor House Hotel, West Auckland in 2008. My wife and I stayed at the hotel in one of their wedding suites on our wedding night, and my wife clearly remembers that the television in the room, which I had switched off at the plug before putting the lights out, came on briefly during the night showing only buzzing static. After a short time the television again went quiet. Strange indeed; we meant to ask the staff about it in the morning but we were running late for our train for our honeymoon in Edinburgh so we never did get the chance to ask.

Along with reports of ghostly children crying, locked cupboard doors opening on their own, strange unexplained odours emanating around the place, and the aforementioned paranormal phenomenon, it is no wonder the Manor House Hotel in West Auckland is thought by some to be arguably the most haunted hotel in County Durham.

Bishop's Palace, Darlington

A grey lady is reputed to haunt the area near to the grotto garden in South Park, Darlington, and her story is a very sad one indeed. The tale revolves around one Lady Jarrett who was once the resident of the one-time Bishop's Palace that stood close by many years ago. Bishops Palace was a magnificent old building but was sadly demolished and relegated to annals of history after the local council decided – for whatever reasons – to get rid. Sad as this is, we have to accept sometimes that these things do happen. However, not all of the echoes and memories of this building are gone. As it transpires, it seems there is one tiny aspect of it all that still remains to this day … and that is the spectral form of Lady Jarrett herself.

For whatever reason, Lady Jarrett had been left home alone at Bishop's Palace. That night, she decided to take an evening stroll in the palace gardens and was spotted by a gang of men while she was enjoying her peaceful meander. Some say the men that spotted her were rogue mercenary soldiers, while others suggest they were a 'roaming band of Cromwellian Roundheads'. Whoever these soldiers were, it seemed they liked the look of Lady Jarrett and decided that they were going to rob her. Legend has it that this group of despicable young individuals chased the frightened young lady through the gardens until they managed to catch up with her inside the palace. After demanding that she give them her enormous fortune the vagabonds spotted an expensive sparkling ring on her finger. When they tried to remove the ring they were bemused somewhat as it would not come off. No matter what they tried to release the ring, the expensive piece of jewellery stayed put.

Being ruthless and having no sense of culpability whatsoever, they removed a sword from its sheath and swiftly severed the hand that bore the ring (some suggest they took the whole arm off). As she lay there bleeding copiously, the soldiers then hurriedly robbed what they could from the great house and made their getaway as they knew the palace guards would have soon been making their return. Lady Jarrett managed to get up and stumble around for a while at the same time leaving a trail of blood wherever she staggered; this included a bloody handprint on one of the stone flags that lay just outside the great house. Shortly after she collapsed into a lifeless heap next to an archway nearby, and subsequently bled to death.

Soon, sightings of Lady Jarrett were seen in and around the site of Bishop's Palace, and it wasn't long after when she was christened by the locals 'the Grey Lady'. The bloodstains that Lady Jarrett left during her dying moments very strangely proved impossible to clean away. Every time an effort was made to rid the stonework of these burgundy blemishes they would not go, according to one local historian. R. A. Luck, the historian in question, also claimed to have encountered Lady Jarrett's ghost himself on a few occasions when

he was a guest at Bishop's Palace. He said that on occasions he heard the pitter-pattering of her bare feet upon the cold floors. He also claimed to have heard the sound of her rustling silk dress as she paced back and forth along the corridors of the old palace.

The arch where Lady Jarrett died was the only part remaining of this great palace complex and it stands proudly in the Grotto Garden at South Park; or so I thought until I visited the area in January 2012 during the compilation of this book. I found out from a local chap who was out walking his dog that the stone arch was deemed a danger to the public as it was falling apart and therefore it was dismantled and removed from the park altogether. I photographed the area where it once stood.

The nearby Town Hall is said to be the site of the old Bishop's Palace. It is still believed today that Jarrett's ghost can be seen around the area where the stone arch once stood with some folk suggesting her one-armed spectre, pouring blood, had once been seen staggering *through* the archway itself. Many others have also claimed to see her ghost glide silently and sadly across the nearby River Skerne. I can't help but wonder if the removal of the stone arch will have an effect upon the appearance of Lady Jarrett's spectre; stone tape theory etc. A rather poignant verse has been penned regarding the sad ghost of Lady Jarrett, which is quite well known to the locals and reproduced herein, it reads:

> This lady, who in violence died,
> Left her blood that none could hide,
> Her desolate vigil still to keep,
> When Darlington folk are sound asleep.

This path led underneath a stone arch that once stood here. It is said to be haunted by the ghost of one Lady Jarret of the former Bishop's Palace after she was robbed and murdered by a 'roaming band of Cromwellian roundheads'.

Neville's Cross Battlefield, Neville's Cross

On 17 October 1346 one of the most famous battles of the north east took place, the Battle of Neville's Cross. On the moors that lie to the west of Durham city, close to Neville's Cross, two armies gathered to fight to the death. A Scottish army led by David II invaded England at the command of the French King, Philip VI. This strategic plan was an effort to divert the English from their campaign in France at that time. As the Scots advanced into England they destroyed many a building, while taking others such as Lanercost Priory. After negotiating the Pennines, they arrived at Hexham and caused havoc and mayhem there, subsequently taking Hexham Priory in the process. They then made a beeline east to Durham. On 16 October 1346 the Scottish army arrived on the outskirts of Durham city and camped near the area where Bear Park is now located. 10 miles away from the Scots camp, an English army gathered, assembled by Ralph de Neville and Henry Percy.

A pre-battle encounter occurred between a number of Scottish soldiers and the English, when *other* Scottish soldiers had been advancing to find their main armed forces – and suitable fighting ground. They retreated back to their main camp to warn the rest of the throng, but it was too late. The English, by now, had reached the most favourable location from which to do battle, which was on a narrow ridge on the outskirts of Neville's Cross itself. This resulted in the annihilation of the Scottish army as they found themselves at a severe disadvantage due to the poor fighting ground they found themselves on. Essentially they were defenceless from the English sub-army of first-rate archers that were perched high on the hillsides. It was these archers that crippled the Scots before they even had a chance to begin. Arrows were fired, swords were viciously thrust into Scottish chests, and axes hacked them to pieces. The Neville's Cross massacre continued until the land was saturated in the warm blood of 20,000 men. Eventually, after hours of fighting, the Scots fled the field leaving their King in the hands of the English. The English had terminated the invasion from the North and the Scots were sent packing back to the borderlands.

Over 650 years later the echoes of that horrific day are still said to be seen and heard, as the battle is purportedly re-enacted in spectral form. Some claim to have seen the ghosts of the soldiers as they do battle for the umpteenth time only ever so silently. Others claim to have heard only the deafening roar of the soldiers as they clashed with each other.

Legend has it that if you were to walk around the actual Neville's Cross nine times, and then put your ear to the ground, it is said that you will hear the unmistakable sound of the battle that once took place there.

An eerie mist lies across the frost bitten valley of Crossgate Moor on the outskirts of Durham city. On 17 October 1346 one of the most famous battles of the north-east took place here: the Battle of Neville's Cross. It is said to have left its mark on the Durham landscape for the chilling sounds of battle cries and the clash of steel on steel have often been heard here as seemingly, the battle between the English and the Scots is psychically replayed over.

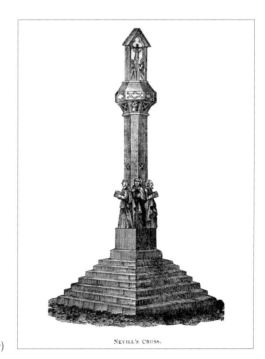

NEVILL'S CROSS.

Neville's Cross; This old marker once stood close by to the battle site as a memorial to the soldiers that lost their lives. It has been replaced with a new marker which still stands to this day. (*Picture courtesy of Newcastle Libraries and Information Service*)

17

North Road Station, Darlington

The railway station in Darlington, known as North Road Station, has long been reputed to be haunted. The station, which is now a museum, dates back to the 1840s and once served the Stockton to Darlington rail service. By all accounts a suicide took place there in-between the late 1840s and 1890 and the individual who killed himself is said to be the ghost that inhabits the station. Upon discovering the dead man's body, he was taken to the station cellars, where he was kept for a period of time until they were able to transfer him to the local mortuary.

In December of 1890 the nightwatchman was on duty when he spotted a man coming out of the porter's cellar. He was wearing old-fashioned attire, including an old-style hat and coat … and with him was a black dog. The nightwatchman then approached the figure, thinking he must obviously be an intruder. No one knows for sure what happened next but it believed that the mysterious figure took a swing at the nightwatchman as he approached him, subsequently knocking him to the ground. Once he was back on his feet, he took a swing at the mysterious figure but, to his utter surprise, his punch went straight through the mystery man.

At this point the unknown visitor's dog went for the nightwatchman and bit him rather savagely. It only ceased attacking him when the mystery figure called the animal off. It is then said that they walked away from the melee, silently … and straight through a cellar wall.

No one believed the nightwatchman's story when he decided to tell it, and everyone presumed he must have been drunk … until they found out that the nightwatchman was a committed teetotaller who suffered no fools. The Incorporated Society for Psychical Research (SPR) – founded in 1882 by a three Cambridge academics to investigate claims of the paranormal, and a society which the author is a member of – were convinced the story held some validity; so much so that they sent an investigator up from London to document the case. After interviewing the witness and conducting his research, he left the North East convinced that what went on that cold and dark night was a bona fide paranormal incident.

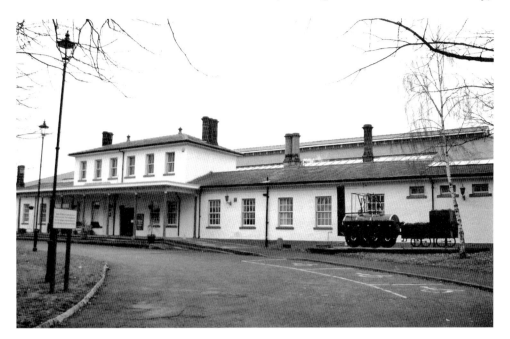

North Road Station in Darlington; the scene of a truly bewildering ghost sighting back in 1890 which led to a visit from the Society for Psychical Research.

The author (right), and his colleague Mike Hallowell, standing at the entrance to the porters cellar at North Road Station during their investigations into the ghosts of NRS.

Dog and Gun Pub, Bear Park

The Dog and Gun public house is in the Bear Park area of Durham. Not much at all is known about the history of the inn apart from that it was once an old former coaching inn. I went to chat with the owners one night in 2008 to find out all about their alleged ghosts. A friend of a mutual friend, Margaret Wilkinson, and her husband, David Williams, ran the Dog and Gun Pub and had agreed to be interviewed prior to an overnight investigation some colleagues of mine had arranged. We arrived at the pub on a cold, snowy night in December and my first impression of the pub – from the view outside on the road – was that of an overwhelming sense of excitement. It looked like a pub that could well be racked with spirits, in both senses of the words.

Upon walking into the pub we were met by the owners and invited to join them in a drink. Of course, alcohol is strictly forbidden prior to, or during our investigations, so it was orange soda all round. The bar, which was quite busy, had a warm and welcoming feel to it and I wondered just what paranormal activity had occurred here. After the bar had emptied I was given my opportunity to chat to the owners. The first thing I asked them was how long Margaret and David had been running the pub, to which she answered 'seven years in April'. I then asked her to answer my next question with a simple yes or no. I asked her, 'Is the pub haunted?' She paused for a moment and said, 'Yes … but I have not personally seen anything.' I then asked her why she *thought* the pub might have been haunted. She went on to say:

'There was one occasion. I never actually saw anything but I *heard* something. I was on my own late at night and was doing the till and [light wise] all I had on was the light that shines over the till. Suddenly I heard a whispering and it occurred to me that I may have locked some customers in the pub, so I put the main lights on and had a look around and found nothing. The whispering, which was garbled and unintelligible, was coming over from the back door entrance at the rear of the pub and sounded like it was more than one person that was engaged in conversation. It was as though a number of people were having a conversation quietly in the corner there. I even went upstairs to check there and found it all quiet. I got my dog and came back down into the bar for a final look around and the voices and whispering had ceased. I took one last look around and then retired to bed thinking nothing more of it.'

I then asked Margaret if anyone else had had any odd paranormal experiences at the pub and she went on to say, 'Not when I worked here, but there was a barmaid that worked at the pub and she often saw it! For years she wouldn't go down in the cellar

because she always said that it was in there, either there, or in the ladies loos.' I was intrigued as to what the 'it' that she had just referred to was. She went on to say that 'it' was a spectral elderly gentleman that wore an old-style long black coat. She went on to say, 'She told me it was an old man, and that's all I wanted to know … I didn't *want* to know any more to be honest'. The author had heard that another 'spooky' happening had taken place quite recently involving one of Margaret's barmaids so I decided to bring this up to find out just what had happened. She went on to tell me;

> 'Yes, that was one of my barmaids and it happened only a year or two ago. Everyone had left the building and I was standing talking to the barmaid. She too was ready to leave for the night but mentioned that she must pay a visit before heading off. I mentioned to my husband that he should just go straight upstairs, and I would finish up in the bar. Just as my barmaid came along the passageway and reached the doorway, she didn't half jump. She told me that she thought Dave had pinched her bottom, but after realising he was not there she became frightened. I could tell she was genuine as I saw her jump when something touched her. She said whatever it was really hurt her and for days afterwards she had a bruise on her backside the size of an orange. It was a long, long time before she would come back inside the pub.'

I then asked if there were any more accounts she could give me that may shed some light as to what was going on in the pub. She paused, thought for a while and then said, 'At one time, there was a relief bar manager that was put in here on a temporary basis and was supposed to run the pub for a few months. Now I don't know why, but after only one night, she and her husband packed up their belongings and left the pub.

The Dog and Gun pub in Bear Park; a wonderful public house with a few more spirits than one previously thought!

Something must have freaked them out so they left, that's all I can surmise. These are the stories you hear … I don't know why they left but I do know they left after only one night.'

I then asked whether or not any odd activity or anything unexplained occurred upstairs in the private living quarters, and was told there had not been. I then asked if there was anything else that might make her think the place could be haunted. She thought carefully for a minute and suddenly remembered something: 'You know, David often gets up in the night and comes down into the bar because he can hear noises and things as if someone is moving around. He does that quite a lot and never actually finds anything … the alarms sometimes trip for no reason too.' These are fascinating anecdotes of ghostly phenomena that the author has heard many times over and in many different places; it seems these ghosts, if ghosts they are, tend to go about their hauntings in a very similar way with traits and behavioural patterns in some cases being almost identical. The night we spent there proved very interesting indeed with some frightening activity being documented and reported; activity which we find hard to dispute. The full detailed report of this paranormal investigation can be seen in my book, *Haunted Durham*.

Witton Castle, Witton Le Wear

Witton Castle and Park is home to one of the finest caravan and camping sites that County Durham has, and proves to be a very popular haunt for tourists from all over the north-east and beyond. Situated in the heart of beautiful Durham countryside, Witton Castle really is a great base for holidaymakers that wish to explore neighbouring areas such as Northumbria, nearby Durham city or many of the other places of interest such as the many wonderful stately homes and historic buildings County Durham has to offer. Amidst 330 acres of beautiful landscape scenery at the foot of the Pennines, this fourteenth-century castle forms the centrepiece of the park and the surrounding countryside. It is home to an abundance of varied wildlife, it is in an ideal setting for contemplation and solitude, and provides a peaceful haven for visitors.

For those that like life a bit more lively, the castle has an entertainment bar and function room that provides revellers with a fine selection of ales, spirits and wines along with 'entertainment nights' such as discos and even bingo for the more mature holidaymaker. Takeaway cafés, gift shops, games rooms and a grocery store are also available to the holidaymaker in the summer season. Stables offer horse and pony rides, child-safe play parks, Laser Quest and Paintball are also all available for the younger generation, making Witton Castle and Park one of the best equipped and 'plenty-to-do' caravan parks in the whole of County Durham. Today the Castle and Park is owned and run by Karen Hague who ensures that during your stay you are looked after well and all your needs are catered for.

Like most castles, Witton has a ghost … in fact it has a few ghosts. In April 2009 I took a trip up to Witton Castle to explore the area and to go in search of its resident phantoms. During my trip I managed to chat to some of the staff, and was also fortunate enough to have a brief conversation with the owner's son, Adam.

I asked Adam if he had personally witnessed any of the alleged ghosts that are said to reside there and he told me that he had not. Adam spends very little time at the castle and informed me that I should speak to the castle's secretary, Meg Armstrong, who knows a lot more in regards to the paranormal occurrences that have been witnessed there.

Upon chatting with Meg, I discovered that there are a whole range of ghosts that are said to haunt the castle. Strangely enough the ghosts don't reside in the usual parts of the castle such as the Great Hall or the Tapestry room, but rather the private living quarters of some of the staff and the basement bar. In regards to alleged ghosts in the downstairs bar, she went on to say:

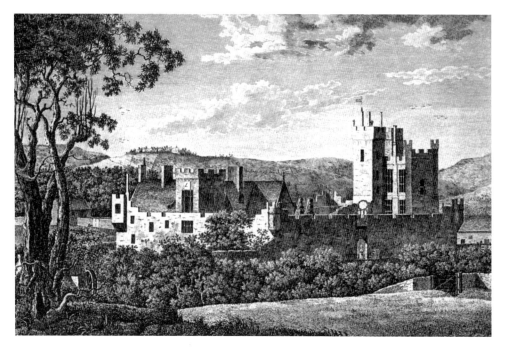

An ancient illustration of the beautiful Witton Castle in Witton-le-Wear. The author had an opportunity to spend the night here looking for ghosts and relished every second of it as he explored the castle from top to bottom. (*Picture courtesy of Newcastle Libraries and Information Service*)

'Well, I have been here over ten years now and people that I have worked with, including the present bar manager, really don't like to come to this area on their own. On one occasion while the bar manager was down in the bar, he got an awful feeling that he was not alone. Not long after, a lemonade bottle that was behind the actual bar was thrown over his shoulder from behind him, and smashed on the floor. The ladies' toilets, which are housed in this area, are also haunted. Another team of investigators that spent the night here reported seeing a peculiar black mist as it drifted out from one of the cubicles and across the room where it disappeared through the wall. They also claimed that a mother and child were walled up behind one of the walls in this area, which is subsequently the cause of a ghost boy that has been seen in this area. The ghost boy tale holds some validity, as there is indeed a ghost of a young lad that has been seen by one of our visitors' children as she was in the loos. After spending twenty minutes in there, the mother of this young child obviously became a little worried and began to look for her. She eventually found her in these loos. When her mother asked where she had been all this time, the young girl replied by saying that she had been talking to a strangely dressed small boy that lives in the castle. There is no small boy living at the castle.'

Very interesting to say the least; she also said:

'They say someone died on the main stairwell leading up into the castle and his ghost is said to have been seen in this area. And outside near the main entrance there has

Tall walls of Witton Castle from the rear. (*Picture courtesy of Andrew Local*)

The Great Hall of Witton Castle. (*Picture courtesy of Andrew Local*)

been horses and a carriage heard as it thunders around the oval shaped drive. There are a few people that have heard that, with the funny thing being that there is actually nothing to see. Only the noises of the coach and horses are heard as it pulls up to the entrance.'

Two other ghosts are said to haunt the castle: one a macabre and sinister-looking man that has been seen quite often in the flat that the owner's son, Adam, uses when he

The Bar area of Witton Castle where unexplained noises and movement were heard during my overnight stay there. (*Picture courtesy of Andrew Local*)

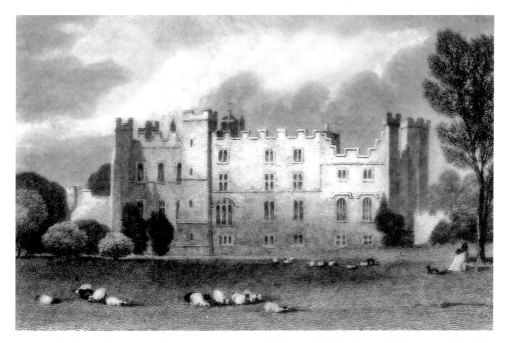

Witton Castle, another rare view. (*Picture courtesy of Newcastle Libraries and Information Service*)

stays over at the castle, and the other being a large horse that has been seen and heard on the castle stairs inside the main entrance, very peculiar to say the least.

During my time at Witton Castle, I experienced what I believe to be one of its resident ghosts while in the main bar area downstairs. I had been outside getting some air, and upon my return to the base room I found it completely empty. I grabbed my camera in order to take a few photographs of the bar area and the adjoining room. As I turned and looked towards the door area I distinctly heard the sound of someone moving around in the area where all our bags were. Footfalls were heard, along with creaking and movement upon the bar room's floor. I also heard the rustling of something that I couldn't identify. I raised my camera to take my picture and found that my newly charged batteries (that had been recharging all day) were drained of all of their power and so I was unable to take my picture. I could still hear the movement coming from in the other room so I went through to see if anyone was there. To my utter surprise, I walked in and found the noises ceased abruptly, and no one at all was there. I really thought that someone had returned to the room, not thinking for one second it was (or could have been) one of the castle's ghosts.

In the distance I heard some voices. I traced them to the beer cellar, whereupon I asked everyone in there, 'has anyone been messing about in the base room?' I was told that no one had been in that room as they were all too busy chatting at the back of the cellar. So, it remains a mystery as to what, or who, it was that I heard moving around. Personally, I think this account adds to the deepening mystery and credibility of the paranormal incidents and hauntings that occur at Witton Castle. Again, a full detailed report of this paranormal investigation along with the historical details of the castle can be found in my book, *Haunted Durham.*

Former MOD Ammunitions Depot, Undisclosed Location

I once read somewhere that the ammunition depot and old Ministry of Defence buildings lie in the deepest darkest areas of County Durham. If you ever go there you will wholeheartedly agree with that sentiment, deepest and darkest being an understatement! The depot in question that features in this write-up was built in 1939 for the Ministry of Defence and was used to store ammunition from a one-time factory which sadly does not exist anymore, although slight traces of it do still remain. The unit which we were visiting was used as a base for the storage of bombs and bullets during the Second World War and is now occupied by Sunderland man Ian Hogarth and used as a storage facility for his many old vehicles which he lovingly restores and repairs.

In early 2010, the Ghosts and Hauntings Overnight Surveillance Team (a team which my regular readers should now be well familiar with) headed off to meet the owner of the former ammunitions depot so we could see the place for ourselves. It was arranged with Ian for us to spend some time in the unit through the night and see for ourselves just what goes on in there. On the night in question we met up in a small village which lies only a few miles away from the haunted unit, and we made our way from there. As the area where this former ammunitions depot is located is strictly private property, and also due to the fact there are a number of very tall fences and locked gates to stop intruders getting anywhere near it, we needed to be taken there by Ian and his colleagues in a rather large, ominous-looking, four-wheel-drive ex-military truck. The journey from [a nearby village] proved very exciting indeed as we drove off into the night, not knowing where the hell we were going! The further we travelled, the narrower and bumpier the roads became. It was clear to us that we were venturing off into the middle of no-man's-land, as whichever way we looked all we could see was the pitch-blackness with almost no light pollution coming from anywhere.

Twenty minutes or so after we arrived I conducted an interview with the unit occupier, Ian, in the hope of gleaning some basic details about the history of the place, the alleged haunting, and what he may think is responsible for them. My first question was how long he had been occupying the unit, to which he replied *nineteen* years. He then told me that he first suspected the unit may have been haunted around *fifteen* years ago in 1996/97 when he was working on a red truck that is, to this day, still standing at the door where it was all those years ago. Ian said that he was up working in the unit one evening doing a spot of welding on the truck. A friend of his, who had accompanied him to the unit, was standing halfway down the building on the inside carrying out some other duty. Ian had completed his welding and decided it was time

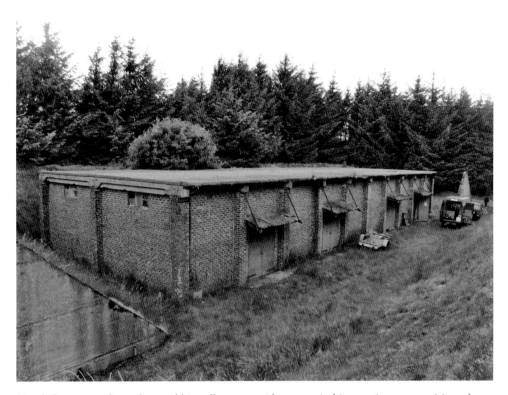

Simply known to the author and his colleagues as 'the garage', this one-time ammunitions depot for the MOD is awash with ghosts and paranormal activity.

he turned his welding machine off. When he bent down to flick the switch, he was bemused to find the machine had been switched off already. Considering he was using it only moments ago, he wondered how this could have happened.

His first thought was that his friend was playing 'silly buggers' and had sneaked up to the machine and secretly turned it off. This of course is a rather unlikely explanation as Ian would have seen him do this, of course; but decided to ask him nonetheless. He shouted for his friend, who answered immediately, and, as Ian had previously said, he was still half way down the unit carrying out his work. Ian asked his friend to come over. His friend downed his tools and made his way towards Ian. When he approached the front of the red truck, Ian asked him if he had been 'playing around with the welder' to which his friend replied, 'No, certainly not'. This, Ian said, was the very first instance of a strange occurrence during his time at the unit. I then asked Ian if he could tell me what else had occurred in the unit.

He paused for a moment, thought for a second or two, and then spoke: 'We've seen a man standing near the door where we bring the vehicles in. He was standing with his back leaning against the wall, wearing jeans, a patterned wool jumper, and with curly hair which was a blonde-gingery colour.' I asked Ian how many people had seen this strange man and was told two people: Ian and his father, John Hogarth. Ian said the two of them laid eyes on this chap and he looked as solid as you and I are now. 'Only thing was,' Ian went on to say, 'we turned our heads away for just a second or

The trail through the trees leading in to 'the garage'. On dark nights you would not want to be here on your own; it is truly terrifying.

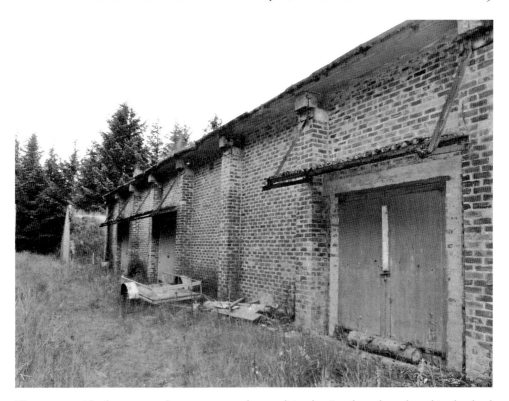

The area outside the garage where strange and unexplained voices have been heard in the dead of night. Near the trees to the left of the image, and behind the unit, is where the phantoms of Second World War soldiers have been seen on two separate occasions.

so, and when we looked back, only seconds later, he was gone. There is simply no way this person, if he had been a real flesh and blood living individual, could have nipped outside and disappeared from view as we went outside to look for him seconds after seeing him standing there; not only that, I recognised him as my deceased friend, Alan Purvis, from Seaburn.'

Interestingly, Alan and his brother had used another of these lock-ups, which is located not too far away down the track from Ian's lock up, and often spent time in it. The thought occurs his ghost/spirit visited the area where he loved to work, and made his presence known in Ian's lock-up. Perhaps he was just popping in from the other side to let Ian know that all was well and also maybe to say hello in his own way. This incident certainly left a mark on Ian and his father and I have doubt he is telling the truth when he says he saw the ghost of his dead friend.

'Anything else?' I asked Ian.

'Yes, my father told me once that he saw someone walking up and down in-between these rows of vehicles.' Ian pointed to two rows of vehicles. 'It passed the old police van up on the right there and then disappeared into thin air. Again, there were only two of us in the building at the time, and I was nowhere near the area where my dad had seen this figure walk. It was very odd,' he told me. Ian then went on to tell me of yet another ghost sighting, which was most strange to say the least. 'While standing up near the

door where we came in tonight, we glanced down the unit to the forth door down, we saw what we could only describe as a "see-through" apparition. We could actually see the outline of a human person but as it moved from left to right it distorted what we could see behind it. This apparition I have personally seen a few times.' To round up my interview I asked what other things occur in the lock-up. Ian said that many things do indeed occur such as the time when they heard the sound of a bunch of keys hitting the floor right next to them.

Spanners and other tools are often heard to clatter upon the floor after seemingly being thrown by the resident ghosts. Ian is sure that these tools could not have simply fallen to the floor after teetering on the edge of a shelf. 'The tools are put away safely, and should never fall naturally off the shelves,' he said. 'Actually, when we go to find out what had been dropped, we never actually find anything out of place; it's as though the things *were* thrown and made the sounds we heard, but the things that we thought had been thrown around are always found in their rightful place, it's really strange,' he said. Not strange to the author, of course. I have heard of this happening hundreds of times before in other cases. 'Knocks, bangs, things rattling, the walls are sometimes thumped too,' Ian continued. 'Tremendous thuds echo around the unit which is quite scary.'

Ian went on to say that one of the most eerie things is actually hearing voices coming from outside the unit door. Full conversations are heard, yet every time Ian goes out to see who is there, the speaking stops and all is silent once more; no one is ever found. Now, I have to be honest here and admit that I have actually heard these very sounds myself during a number of overnight investigations that the Ghosts and Hauntings Overnight Surveillance Team have carried out and believe me, they are really odd. We heard the 'disembodied voices' (for that is what we believe them to be) in the early hours of the morning, and when we looked outside, no one was there. It was a total mystery to us and it certainly backs up what Ian had said about it.

It's not just the building that is reputedly haunted by all accounts, but the surrounding land too. There are stories of ghostly Second World War soldiers being seen in and around the dirt tracks and trails that festoon this area of land. The MOD occupied this land for the duration of Second World War and kept it for many, many years after therefore the military presence here on this land lasted for quite some time. One account goes on to say that two females and one male (three people in all) saw two men dressed in Second World War soldiers' uniforms (I am not sure how old these witnesses were but they were related to Ian's aforementioned friend that was a witness to the welding machine being turned off. They were visiting the site with Ian's friend and had decided to have a little 'walk about' to explore the area). On their little walk, they ventured to the far end of the unit where there are two great triangular stone structures. Through the triangular structures there is a small clearing surrounded by thick woodland and it was here they reported seeing the army personnel. As they got closer to them they watched in awe as they vanished into thin air. This is not the first time the ghost soldiers have been seen in this area. John, (Ian's father) also saw two military men and decided to go over to speak to them. He got to within 10 feet from them and, similar to the three other witnesses of the ghost soldiers, he watched in horror as they vanished in front of his eyes. All in all there have been eight people

(not including the investigative team's strange accounts) that can lay testimony to the strange happenings of this lock up and the surrounding land.

Interestingly, about half a mile away from the unit stands a farmhouse which has also been subjected to paranormal activity. The house has a 360-degree panoramic view of the surrounding land, so you can imagine the farmer's surprise one night when he saw beaming headlights shine through his windows and heard the sound of a car pulling up in front of the house, on the gravel that lies outside his property. The farmer thought that he must have had a visitor and so went outside to greet whoever it was, only to find nothing at all and no one there. No vehicles of any kind were outside the farmhouse and the night was as quiet and still as could be. Upon checking for car tracks in the gravel the next morning, he found no traces of any vehicles on his driveway; very strange to say the least.

Our research team to this date, July 2011, has spent three nights investigating the unit and on all three occasions they have emerged the following morning convinced, and armed to the teeth with evidence, that something really odd is residing there. I never actually took part in the first investigation as I was booked to carry out a talk in London on my work as a paranormal investigator, so I think it is best that I only sum up the investigations that I personally witnessed strange phenomena on. The usual baseline tests were carried out on the premises and many pre-investigation checks were performed so we pretty much knew everything that was needed to know about draughts, winds, noises we might hear etc. No EMF anomalies were discovered during our baseline tests, so if we were to get any strange electromagnetic field readings, we would know that an anomaly was taking place within the natural electromagnetic field. That done we were ready to begin.

We split up and situated ourselves in different areas of the unit. Since it was one big room, and technically we would all be within sight or sound of one another, it was vitally important that we were silent in our investigations, and silent we were. Video cameras were set up in various parts of the location and trigger objects were placed in the hope that any residing spirits would kindly move them for us. It was not long before we heard our first sounds: a tapping noise that occurred every few minutes or so. These were, of course, detected by the investigators during our 'silent time', and were not heard during the periods we spent chatting before the investigation began. We soon discovered that the noises were due to a slow dripping that was occurring over the top of one of the covered vehicles. Water was dropping down from the ceiling and landing quite loudly on some plastic sheeting that was covering an old vehicle – debunked.

The next sound, which was heard on a number of occasions throughout the night, came in the form of a loud guttural breath, something which the team encounter on a lot of their investigations. On one of these occasions, during a period when everyone was grouped together next to the old police van, a loud breath was heard to emanate from down the corner of the unit where we know no one was standing. Poor old Mark Winter was closest as he was on the end of a long line of people standing between the vans. Between him and the sound of the breath, there was nothing but total darkness. I subsequently decided to venture down on my own with my night-vision video camera and sat in the darkness for a while, while the others were carrying out other

experiments. During this 'stint' yet another strange sound was heard by all present, and, like the guttural breaths, was recorded on tape as evidence. This sound came in the form of a whistling! Ian had forgotten to mention to us that whistling is quite often heard in the unit when he is working in there alone. 'Not so much in tune,' he went on to say, 'but more like a few random notes.' This was just like what we heard during the course of our investigations.

Another sound anomaly was, of course, the voices. I mentioned this earlier on in the write-up and it was a phenomenon that all members of the team, Ian and his friend, accompanying us on our investigation, heard. Ian's friend, Carl, was a die-hard sceptic and was having none of it ... until he heard the voices! He was the first person outside in an effort to debunk the ghostly voices by hoping to find intruders on the site, but lo and behold, he found nothing at all. In actual fact, he looked like a 'ghost' in the respect that he was white as a sheet when he realised the voices we all heard seemingly came from the ether. From that point on he was convinced that paranormal happenings were indeed occurring; but it was not over yet. During stints of 'calling out' to the spirits, asking them (nicely) to perhaps perform for us, we heard what we presumed were many small objects such as screws, nails, nuts and bolts being thrown around in the darkness and making a hell of a din when they came to land. Now, everyone was together at this point and everyone was filmed sitting in the unit. The sounds of these objects being thrown around are clearly heard on the video camera, which also shows everybody hearing them. It also shows nobody throwing them. Now, we know there was no one else in the unit except those that were clearly in view on the video camera, so it remains a mystery to us, just who or what was throwing around these objects. You, the reader, will have to decide for yourself whether or not we were experiencing true paranormal phenomena.

Drew Bartley and Fiona Vipond had recently invested in a 'ghost hunting tool' known as the K2 EMF meter and had brought this new piece of gadgetry with them on the investigation. When the K2 first came out on to the market it was dubbed as the 'ouija board in your hand'. The theory behind the K2 is that when a ghost or spirit is thought to be close by, the lights on the meter light up to indicate this, just as a gauss meter whistles and spikes on the older EMF meter. Drew and Fiona swear by it, as do millions of others around the planet, but I have my reservations. Like all ghost-hunting gadgets and gizmos I think they are very interesting, but their uses in regards to ghost hunting are strictly hypothetical. Until someone can prove otherwise I will continue to treat these objects as such.

Anyway, a K2 session was held near the police van which, if I have to be honest, yielded some pretty amazing results on the surface of it. Questions were asked and the K2 meter seemed to be responding by lighting up and answering the questions. It lit up when questions were asked, yet sometimes it stayed dark. When everyone was silent, the K2 did not light up either; interesting. The K2 only responded to certain questions and never responded at all when all was silent. I am still not 100 per cent convinced that it is a ghost detector or indeed a bona fide method of communicating with the dead, but I will keep an open mind. The K2 told us that a spirit was connected to the old police van, or should I say the *alleged* spirit connected to the police van told us via the K2 that he was there. This spirit went on to say that he was once transported

to prison in the very police van back in the early 1970s after committing a number of murders. I will be a lot more convinced of the K2 as a spirit communication device if we can find records of this; Ian has the relevant powers to check this out and will be doing so in due course.

As much as the K2 meter is intriguing and a very interesting tool to use, I prefer the good old-fashioned ghostly phenomena such as objects being hurled around, and seeing an apparition or two; and this is what exactly happened to me during my first investigation there. Taking part in a group vigil down in one end of the unit, we were all standing together filming and generally observing the area. I happened to glance up at Drew Bartley who was holding his video camera up at chest height, with the lens facing the floor. His view finder was open and it was clear to me that he was reviewing a piece of pre-recorded footage. As the camera was switched on and in 'playback' mode, the view finder was facing up. It therefore cast a good amount of light up his chest and face area and it was at this point that I saw a strange face – not of our team, nor was it Ian or Carl – peering over his shoulder.

The face I clearly saw was chubby with a receding hairline and a balding head. This person was so close to Drew that his left cheek was almost touching Drew's right cheek. His chin seemed to be resting on Drew's right shoulder and, as strange as it sounds, it seemed as though this ghost was looking over Drew's shoulder to watch the footage. I nearly had kittens when I realised I didn't know who this person was. The reality struck that it may well have been an apparition of sorts. No sooner had I noticed this stranger looking over Drew's shoulder, he vanished in a millisecond. My reaction to this ghost sighting – for that is what I believe what it was – was filmed and is part of the overnight investigation DVD that was made about these hauntings.

My second investigation there (the team's third) was just as eventful as the previous one and more strange things that we would deem as 'paranormal' were documented. More guttural breaths, footfalls and the shuffling of feet were heard in areas where we knew nobody was; noises, more whistling, and unexpected ice-cold breezes were felt despite the fact it was a warm July night in 2011. Out of all the things that had happened that night there is one incident that stands out like a sore thumb, which scared a [then] member of the team witless. An object was seemingly thrown across the unit and landed close to a number of investigators – way too close. This object was not the usual small object as previously mentioned (nuts, bolts, screws etc.) but was a lot bigger and heavier. The event occurred when we had split up to investigate different areas of the unit. Our team medium was situated in the bottom corner of the unit with a friend who had come along to investigate the premises with us when suddenly something quite large struck the floor right next to his foot. It made one hell of a din and resulted in him and his friend screaming out with fright. I can't reproduce his exact wording but needless to say it included a few 'F's. Everyone present on the investigation that night heard this tremendously loud crash and we all thought someone had tripped over something, knocked it over and fallen – it was that loud.

It turned out that no one had tripped or fallen; in fact, everyone was quite still. What the medium found after the light had been turned on horrified him somewhat as it turned out to be a 2-foot-long steel rod with nuts and bolts securely fastened to each end. This object had been hurled across the room in the darkness and had narrowly

The heavy steel rod that was mysteriously thrown during a vigil inside the lock-up one night, narrowly missing a fellow investigator. Needless to say, if it had actually hit him (or one of us) it could have caused serious injury, or even death!

missed him and his friend. Now, it goes without saying (but I will say it anyway), that no one – I repeat – no one in the unit that night, or any night for that matter, would have been so damn stupid as to throw something like that. In fact, no one would have thrown *anything* as we are simply not like that. So who or what threw it? Our team medium was, and still is, convinced that it came hurtling over from *somewhere* as opposed to it just falling from a shelf, and so was his friend. Drew, on the other hand, suspected there may be a rational explanation for this and was not entirely convinced it was paranormal in origin. I was nowhere near the medium when the incident occurred and neither was anyone else for that matter. Combined with the fact that it was pitch-black and no one saw anything either we can only come to the conclusion that it remains an unsolved mystery.

I think if you look at the bigger picture, however, of all the reports of paranormal activity that this unit has undergone over the last nineteen years, then it may be likely that the steel rod was indeed hurled across the room by an agent or a force that is still unknown to us mere mortals. As in all cases of the paranormal, we have to go where the evidence takes us. It's not a case of being a sceptic or a believer, but more of a case of being completely neutral. I also feel it is still best to remain open-minded too. The strange happenings at this amazing old lock-up in the wilds of County Durham are still being reported to this day, and we are still in contact with Ian in regards to them. One day, we will no doubt return to reinvestigate and continue to document the strange goings-on at this former Second World War ammunition depot. With any luck, we might just catch an apparition on film.

Durham Prison, Durham City

Durham Prison, was – and still is – a renowned place of incarceration, but back in its earlier days this detention centre carried out many executions which of course don't happen anymore. It saw more than ninety of its convicts hanged from the neck for various crimes ranging from serious assault to cold-blooded murder. One of Durham's most infamous inmates was the notorious murderess, Mary Ann Cotton. She swung by the neck here in 1873 for the murder of her stepson, Charles. He was found to have ingested arsenic, probably via a meal that Mary would have prepared for him. This macabre finding led to one of the most notorious and certainly the biggest murder trial the north-east of England had ever seen. Mary was subsequently accused of killing many more people, including some children, but she always denied this. Over twenty people that either knew, or were related to Mary in some way lost their lives over a period of two decades and all in suspicious circumstances. Although it is thought she probably didn't kill *all* of the victims, the authorities were pretty damn sure she did kill some of them, and had evidence to support it. This was enough to condemn her to death. Although she denied all charges, her protest fell on deaf ears and was sent to the gallows to die; and die she did.

The current prison was built in 1810, costing £2,000 to replace an earlier jailhouse that stood on the same spot. The money was guaranteed by one Shute Barrington (1734–1826) who was then the Bishop of Durham. By the end of July 1809 the building of the new prison had begun. Sir Henry Vane Tempest (2nd Baronet, 1771–1813) laid the foundation stone and the prison was eventually finished by the English architect and surveyor, Ignatius Bonomi (1787–1870). By 1819 the prison had over 600 holding cells and had taken its first consignment of inmates.

With so much misery and death, despair, and dread, is it any wonder that lost souls still abound within the old prison walls. If it is true what they say about the souls of individuals staying behind after losing their physical lives, especially if when in their physical lives they suffered immensely, then the prison must be full of them. If so, then you would assume that reports of ghostly visions and smoky apparitions will come in from time to time … and guess what? You would be correct, they do.

The most famous ghost of Durham Prison, *the* most relayed ghost tale, dates back to the winter of 1947 when two burley inmates became involved in a set-to with one another. A number of smaller arguments had occurred between the two residents of Her Majesty the Queen, and because of this one of the two inmates decided to get 'tooled up' for a future argument. Following his kitchen duties he somehow smuggled a carving knife back to his holding cell, and when the next bout of bickering broke out, he subsequently pulled the knife out from wherever he had hidden it and began to

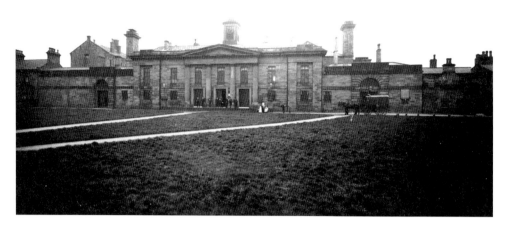

Durham Gaol; a renowned place of incarceration and a one-time place of execution. (*Picture courtesy of Newcastle Libraries and Information Service*)

repeatedly plunge it into his unsuspecting victim. The terrified casualty had nowhere to go as the cell door was securely locked so he could only scream hopelessly for help from the guards as he was sliced open. Following all the kerfuffle the murdered inmate was removed and the remaining prisoner was taken from the cell. It was likely that he was either placed into solitary confinement or immediately onto death row.

We are not sure how long after the murder had taken place the cell was reused, but we do know that it was. Eventually, a new inmate of the prison was placed into the cell where the stabbing had taken place. If this new inmate did not want to be in prison (most wouldn't, I expect) at this point, then by the morning he would be even more anxious to get the hell out of there for that night the new prisoner saw something that he would never forget.

It is reported that during the night the new prisoner awoke from his slumber to see two men in his cell. The two men were engaged in a fight, with one of the men repeatedly stabbing the other with a huge knife. The new prisoner sat there in total terror as he watched this spectacle – which was reported to have been played out silently – run its course, before the two men in his cell slowly began to vanish before his eyes. This was the ghostly re-enactment of the brutal murder that had taken place there some time back. By morning, the guards on patrol found the new prisoner in his cell rather disturbed to say the least. He was in the corner of the cell, cowering, shaking and gibbering like a madman. The terror-stricken prisoner blurted his story to the prison guards and insisted he be moved to a 'non-haunted cell'. Word soon spread throughout the prison that this cell was indeed possessed by evil forces and no one would dare go in there. They would sooner fight the guards to the death and be put in solitary confinement if needs be, than spend a night alone in the haunted cell. This holding cell on the ground floor of the prison was soon turned into a storeroom and abandoned as a 'cell' because of the sheer reputation it had. It was closed down and converted it into a storeroom for linen and other such effects. To my knowledge, the ghosts have never been seen since; perhaps my dear reader, this is because there was no one ever in there after this point, to see them?

Killhope Lead Mine, Upper Weardale

Killhope lead mine is located in the heart of the beautiful North Pennines between Alston and Stanhope in upper Weardale and is surrounded by acres of lush countryside, woodland walks and aesthetic beauty. The mine was opened in 1853 and for fifty-seven years the mine was a thriving industry run by locals and supplied lead all over the north of England and beyond. In 1910 the mine was closed only to be reopened for a few years sometime between 1939 and 1945. The mine's giant waterwheel was built in the late 1870s and was one of many waterwheels in which mines such as Killhope would use. It is now the only surviving waterwheel of its kind.

In 1980 restoration work began at Killhope and today it is the one of the finest examples of lead mines that can be visited; a museum and popular visitor centre in which you can go and see how this Victorian mine was once worked. The mine itself tunnels deep under into the solid rock and earth of the North Pennines and a cavernous and hollow labyrinth of tunnels and passageways are there to be explored by those brave enough to venture down into the dark, dank catacombs of yesteryear. On ground level there are a number of edifices and buildings known as the miners' quarters, which are now museums, and visitors today can see how the miners would have lived. Not much has changed and when one walks into the rooms it is like going back to those good old mining days.

In regards to ghosts at Killhope, no one is 100 per cent sure if the area or the mines are indeed haunted but there have been *some* strange occurrences reported, leading me to think they may just well be. Staff have reported objects being displaced and moved about in the miners' quarters throughout the night. When opening up in the morning it was found by the staff that the old-fashioned draughts board and draughts pieces were moved from where they were originally left the night before. Chairs and old furniture have also been found 'out of place', yet no one had been in to move them. I have had some first-hand experience of the ghostly phenomena at Killhope mine during visits there back in 2003/04; specifically in the miners' quarters and, oddly enough, it was related to the draught board.

So who could potentially haunt the area then? Over the years there have been a number of recorded deaths at Killhope. In 1864 it is reported that a mineworker, Graham Peart, fell to his death while working high up on a ledge. By all accounts he was distracted by something, lost his footing and fell, which ultimately sealed his fate. This account was told to me first-hand by one of their staff members during one of my many visits.

Another recorded death at Killhope mine is that of a certain Thomas Harrison who was blown to bits in March 1878 while working with gunpowder; he was only

Killhope lead mine in the North Pennines. (*Picture courtesy of Newcastle Libraries and Information Service*)

nineteen years old. Another accidental death relating to explosives occurred here resulting in the death of one John Hodgson (aged fifty-three) in November 1876. He had drilled a hole in the mine wall and was filling it with his charge of powder when his candle accidentally exploded it – destroying him in the process, with it. Paranormal investigator and author Rob Kirkup claims that one of the spectres could be that of a former miner named Thomas Heslop, who died on 18 September 1879 after becoming trapped in the giant water wheel and being torn to pieces as it moved round with him trapped inside it. Having done some research into the deaths at Killhope mine I could only verify two of these aforementioned names, and that is Thomas Harrison and John Hodgson. However, my source of information does specify that 'this collection of names is by no means complete', hence there could be a number of candidates for the identities of the ghosts of Killhope. Could these people still be here at the mine, getting on with their everyday duties unaware that they are dead? Or is it someone else; someone else who perhaps loved the place so much they simply did not want to leave?

Another legend and a potential candidate for a ghost is that of an unknown woman who many years ago wandered off into the deep woodland in search of her husband. She was never seen again and it is said that on dark, foggy nights you can hear her calling out for the husband she never managed to find. Perhaps she still walks the woods in vain, looking for her long-lost love? This story, however, lacks credibility, with no records of any woman going missing or of any man for that matter. No one knows when or indeed where this account originated, although there has been a report

or two of a woman's harrowing scream emanating from deep within the forest. Again, I have had first-hand experience of this and might be able to offer an explanation for it.

As mentioned earlier in the text, I have had the pleasure of spending the night at Killhope mine; this was due to me being an early member of a north-east-based ghost hunting team called the North East Ghost Hunters. The (then) team leader had arranged the investigation with the owners of the mine, and we were all looking forward to carrying out the investigation. Having said that, I still felt a little apprehensive about spending the entire night in one of the darkest and most foreboding places in the north. When we arrived we were shown to our base room, which was one of the vigil locations. This particular location was the room in which the draught set and other effects had been mysteriously moved. As we were getting settled in, so to speak, an investigator (Drew Bartley) tried to take a photograph of the draughts board, but for some strange and unknown reason his camera kept on spitting out the batteries! This happened a few times and it baffled everyone who was there. On one attempt, the batteries almost came all the way out the camera. Then, to add to the mystery, when he took out the batteries to check the camera, the lights on the camera were still coming on! Possible camera malfunction or ghost intervention? The thought crossed my mind that a little residual energy left in the camera from the batteries could have accounted for the lights coming on after the batteries came out, but why the batteries fired out the camera in the first place remains a mystery. Others in the room at that time reported feelings of sickness and dizziness which strangely subsided after they left that room. It was looking to be an interesting night.

After we had set up we decided to venture around the Killhope Mine site. Before we headed out we left an infrared night-vision video camera recording, trained on the draughts set in the hope that we would catch some paranormal activity; perhaps film some of the pieces moving. We headed out and around the mine site and ventured to where the big iron waterwheel is and some of the outbuildings. On our way out the oddest thing occurred. I, and another investigator, both thought we heard the voices of two men talking or muttering, coming from near our base room area in the darkness. Could it have been the echoes of our own party? We will never know for certain, but I recorded the incident none the less. After an uneventful hour or so of checking out the area we returned to the base room for a break. It was at this point when two of the investigators and I all heard what can only be described as a loud howl or scream coming from the mine wheel area or from within the woods – we could not determine. Could it have been a fox, the phantom lady of the forest, or perhaps the scream of a trapped man in the mining wheel? The thought crossed my mind.

The likelihood is, is that it was a Red Fox screaming. If you have ever heard a fox screaming you will no doubt compare it to a woman screaming. In the night when it is pitch-black and you are nervous because you think you are in haunted wood, that sound would send shivers down your spine, as it did with us. If the wood in question is reputed to have a ghost of a lost woman, well... need I say any more? I think I can safely say that the mystery of the screaming woman of Killhope Wood is now resolved; at least in my eyes it is. It was not long, however, before we all heard another very loud screech, scream or a wail. Again, some thought it sounded like a fox scream,

The entrance tunnel at Killhope mine which led to the underground labyrinth of tunnels and chambers. Sadly, on our investigation, entry to these vaults was denied due to health and safety reasons.

while others said it *could* have been the sound of steel moving and scraping, like the mine wheel turning, or perhaps an echo of it moving from bygone days. This scream sounded different to the first one we had heard, but the Red Fox keeps coming back to mind. Whatever it was, it sent shivers down the spine.

Later on in the investigation another odd experience was documented. After we had been for a walk up in the pitch-black haunted wood we made our way back to the miners' quarters for another rest. During the descent to the steep wooded path, another investigator and I became aware of someone walking down the path behind us. Since I was at the back of the group I knew it was not any of them. I heard a footfall or two sharply followed by a grunt or a breath. When I turned around I could see nothing but the blackness of the night so I shone my torch to see what was there. At this point it all fell silent and no one could be seen; the investigator with me at this point – who I shall keep anonymous, you know who you are – also said he heard these footfalls and grunts coming from behind us. He heard them more clearly than I as he was using specialist sound enhancement equipment. I still have this taped account myself and this investigator recorded on a dictation device which was discussed at length back at the base room not long after it occurred; it was quite an unnerving experience.

Later on, a guest investigator/writer from the *Fortean Times* had the idea to steal one of the many miners' forks when we left the hut for our next walk about; this was

This image shows the miners' cutlery after they had been paranormally moved during our investigations there, and while nobody was in the room at the time.

The draughts board inside the miners' quarters which has been subjected to paranormal activity.

an attempt from him to aggravate any spirits that may have resided in the miners' quarters into an outward manifestation. This seemed a very good idea at the time and proved to be very interesting. The *Fortean Times* writer told us that the forks and other eating utensils in the days of the miners would have been very precious indeed to them and arguments would have no doubt broken out over these possessions. To tell the alleged spirit that *he* was taking a fork away from them would hopefully produce some paranormal phenomena. Before leaving the quarters one last time we set up the draughts board and some eating utensils on the table. We left the old cutlery on either side of the plates and some more next to the draughts board. When we returned it was noted by one of the investigators that the forks next to the draughts board on the table had been crossed over into an X shape. No one had touched them and they were left parallel before we went out. Isn't it amazing how one individual said he was taking away a fork to aggravate the spirit, and lo and behold, we get some good phenomena relating to the old cutlery?

Earlier in the section I said that it is not known for sure if Killhope mine was haunted. Now I have been and investigated the area first-hand I can say with conviction that it could well be. A number of really strange things occurred on that night. Granted some of the things *could* be explained, but there were a number of other such incidences that to this day cannot be. A lot more research is needed there, however, before any final conclusions are made.

Jack Arthur of Spring Lane, Shotley Bridge

A one-time local chap, Jack Arthur, is well known in the area around Spring Lane and Snow Green Road. Jack worked at the Shotley Bridge paper mill which was not far from where he lived, which was actually on Snow Green Road. Jack would leave his house every morning at the exact same time – 7.30 a.m. – and by all accounts you could set your watch by him. It is said that Jack was a bit of a gambler and a drinker, and spent much of his time in the local boozer playing cards – quite successfully, we are told – and pouring copious amounts of whiskey down his throat. He lived with the local postman, a man named Mr Rutherford, who was also his landlord, and Rutherford disapproved of Jacks after-work activities. By all accounts they argued a lot about it. One winter's night in 1895, an argument was overheard by a neighbour, in which Mr Rutherford was heard threatening Jack Arthur. Amongst other things, he was said to have told Jack that he was going to evict him from the house where they lived. Jack left for work the next morning at 7.30 a.m. promptly – as usual. However, he never reached the paper mill; sadly he was never seen again. No one ever found out what happened to Jack Arthur and I am led to believe a body was never found.

Seventy-five years later, it appears Jack Arthur began to make himself known back in the Snow Green Road area and on Spring Lane, as a ghost. In December 1970 it was reported by two separate postal workers that an eerie presence began to make itself known in this area. Having done the rounds there for many years previously and not feeling anything untoward, they both found this new, unexplained anxiousness rather disturbing to say the least. One of the postal workers, a man called Joe Patterson from Consett, claimed to have actually seen a ghost in this area. After rummaging around in his post bag looking for some letters to post at a nearby house, he became aware of a figure wearing 'old-fashioned clothing' standing silently on the other side of the road. He watched the figure in trepidation as it slowly and silently disappeared into thin air.

Little did he know it at the time, but the other postal worker – a Nora Conroy from Bridgehill –had recently been moved to a new delivery round, and had also sensed the eerie presence along this street. Although she never actually saw the ghost she said she most certainly sensed it and it terrified her – hence the request for a different delivery round. The interesting thing about these two accounts is that they both occurred at 07.30 a.m. Neither postal worker knew of each other's encounter, nor did either of them know that the missing man from seventy-five years earlier religiously left his nearby abode at 07.30 a.m. on the dot to leave for work. It's also fascinating to also note that Jack disappeared in winter, which coincides with the spooky encounters, which occurred in the December.

I am in no doubt that this was the ghost of the missing man, Jack Arthur, making his presence known, but one wonders why he appeared seventy-five years later, and why he made his presence known to two postal workers when he could have spooked just about anybody! The thought occurs that he may have showed himself to postal workers in particular in an attempt to uncover the truth about his disappearance. This makes sense as, if the reader will recall, he was heard fighting with his landlord who was also a postal worker. This postal worker, Mr Rutherford, could have been the last person to ever see Jack … alive or dead! Perhaps this was Jacks pathetic efforts to subtly reveal a murderers identity. What puzzles the author, however, is why he waited seventy-five years to do this? Further, if Jack was murdered then why have his remains never been uncovered? Are they still hidden away in some place just waiting to be found? Answers on a postcard.

The Old Bailey Ghosts, Durham City

Described by the architectural historian, Sir Nikolaus Bernhard Leon Pevsner CBE (1902–83) as 'the best streets in Durham', the North and South Bailey really are the counties finest areas. Tucked nicely away behind the castle and cathedral, these ancient streets are home to a number of old houses that were once used by the military and police personnel. Their people, by all accounts, were exclusively employed to reside here so they were on hand to defend the city from all kinds of physical attack. These were homes with great significance and they are still lived in to this day.

On the North Bailey there is one particular house – we are not sure which one exactly – that was once owned by the former Durham city chief of police. It has been suggested that this house was, and still could well be, the home to a gentle old ghost of an elderly man. On the lower floor of this house there is reputed to be a cellar where the aged phantom has been seen emerging from. Dressed in a cap, a worn and dirty white shirt, and a pair of black trousers, this delicate old fellow has been seen hunched over and seems to walk around with difficulty as though he is/was in quite a lot of pain. This sad old ghost – to the best of my knowledge – has only been seen on a small number of occasions; and they were many, many years ago now, with no recent sightings being documented. Sadly, it is also a mystery as to who this old chap is and why he may want to haunt this area.

One presumes he may have lived in the old house at one time in the distant past and his frail shade still frequents the area in search of eternal rest. It sounds as though this gent, whoever he is, is stuck between two worlds with his transition to the other side not being as successful as he had maybe hoped. If you are ever in the vicinity of the North and South Baileys keep your eyes open and your ears to the ground, for you just might see him. If you do, be sure to ask him who he is and what he may want... I, for one, would love to know. Interestingly, it is also believed that the hunched ethereal form of the old man is not the only spectral resident in this area. Reports of eerie phantom school children said to be fully clad in old-fashioned uniforms have been observed in this vicinity; a musical artiste that plays his spectral instrument has been seen, along with a mysterious woman that no one seems to be able to describe – lord knows why. It seems to me that if this is all true, then this street is most certainly awash with ghosts and is more historical in a respect that you wouldn't originally think.

The North Bailey in Durham city, haunted by a ghost known as 'the crooked spectre'.

The Shakespeare Tavern, Durham City

Located on Saddler Street in Durham city centre, the Shakespeare Tavern is not only Durham's smallest pub, it is also the oldest, and reputedly the most haunted too. Quite a nice addition to the curriculum vitae wouldn't you say? This old and atmospheric wooden-floored and walled inn, which was built in the late 1100s, was renamed the Shakespeare Tavern (so they say) back in the days when this particular 'neck of the woods' was rather well-known for its theatres and its theatregoers. People would often frequent this 'olde worlde' inn before – and after, I dare say – the dramatic performances. I can only surmise a lot of these plays were from the pen – or should I say quill – of William Shakespeare, hence the pub's name.

There are, by all accounts, quite a few ghosts here. The first spectral denizen resides in the main bar area on the ground floor. A barman that worked at the pub a few years back was terrified out of his wits one day when he was cleaning up the area. No one was in this section of building with him at the time as it was prior to opening. He was happily getting on with his chores, collecting the glasses and emptying the ashtrays from the night before, when he suddenly became aware of someone else being in the room with him. He caught a glimpse of a figure out from the corner of his eye, but thought nothing of it until he realised, seconds later, that he was in the building alone. He quickly turned to see who was there and was dumbfounded to see – in full vision, this time – a black anthropomorphic apparitional form. The otherworldly being drifted around a corner and disappeared out of sight and the barman bravely gave chase; however, to his surprise he could find no one else in the building. The figure had seemingly vanished into thin air!

During a lengthy discussion with the pub's owner, Paddy Solan, he told me about a number of other strange and unexplained incidences that have occurred at the Shakespeare's Tavern. One morning he woke from his slumber after a very hard night's work to feel somebody sitting on the bed and behind his back. 'The bottom of his bed', he said, 'was clearly being pushed down upon as though someone was sitting there'. Not only that, he told me that he 'could feel whoever it was sitting up against his leg' as he was lying there with the quilt pulled taut over him. He froze for a while, wondering just who the hell this could have been as he was in the flat, which is over the main bar, on his own – or at least he *should* have been. A little scared, but courageous, he leaped out of bed and spun around to see who was there. He found no one in the room with him. Being quite sceptical in nature, Paddy tried to dismiss this event or at least explain it away but somehow but he could not. His conclusion now is that he woke up that morning with a ghost sitting on his bed! It's as simple as that.

The Shakespeare Tavern on Saddler Street, Durham city. The author has it on good authority that this pub is indeed haunted.

Saddler Street, Durham city.

His wife, Irene, had also encountered one of the inn's resident spectres not long after they had moved into the premises back in November 2005. The pub had been closed for a week or two so that essential building maintenance could be carried out and it was during this first period that she had her first encounter with the paranormal. She had nipped upstairs to the flat to get something that she needed at that point, and it was during her time in the apartment that she had this experience. While she was seeking out her desired object, she distinctly heard the sound of heavy footfalls making their way along the passage. At this point, she presumed the footsteps were being made by one of the two builders that were on the premises at the time, but after calling out to them to see what they wanted, she got no reply. She quickly walked into the passage area where she had heard these 'footsteps' and proceeded to look around; she found no one there. She called out again and still no one answered.

She then ventured down two flights of stairs to the ground floor and found the two labourers working hard. She asked the two men what they had wanted, and why they had been upstairs in her flat, but was surprised to hear that they had *not* ventured up into that area of the building. They categorically denied being anywhere near the private living quarters and Irene, thinking about this carefully, believed them. If they were upstairs and in this area, she thought, there would have been no way on earth they could have got back downstairs to their work stations *without* her hearing them making some noise. By the time she had ventured into the area where she heard the footfalls, all was silent, apart from the distant sound of 'graft' on the ground floor. As she got closer to the ground floor it was clear that the two men were indeed hard at work. Her husband Paddy was not in at the time, so she believed that she must have heard one of the pubs ghosts as it made its way through the upper levels of the inn.

My Grandfather's Clock, Piercebridge

Many, many years ago, when I was a young whippersnapper of a lad, I would often partake in music lessons at my school with one Mrs Mary Bowmaker, my music teacher. Week after week we were forced to sing songs from out of a song book while Mrs Bowmaker happily played away on the piano. One of the songs the class regularly sung was called 'My Grandfather's Clock' which was penned in 1876 by an American songwriter going by the name of Henry C. Work.

Just about everyone has heard of the song, but I wonder how many people realise it is actually based on alleged paranormal occurrences that occurred in an old seventeenth-century inn right on the border of County Durham and North Yorkshire. The inn is called the George Hotel and stands in the small village of Piercebridge. It was here where two brothers going by the name of Jenkins once lived and ran the pub, which had been in their family for many years. In the lobby area of their pub was an upright long-case clock (nowadays known as a Grandfather Clock) which was purchased and brought into the inn on the morning of one of the Jenkins brothers' births and kept perfect time from the day it was bought. Never did the clock slow or stop in all of the years the brothers lived with it, and owned it. This was a fine achievement for the actual horologist that made it – who incidentally, was a craftsman from Darlington.

Strangely, when one of the brothers sadly passed away, the clock began to slow down and would not work the way it once did. Quite often the clock was fixed but it always began to 'act up' again and never again did it keep good time. The remaining brother (one presumes the clock was brought into the house the same day *this* chap was born) lived till the ripe old age of ninety and when he died; the clock ceased working altogether – never to go again – as the song so aptly puts it. It is said that one day in 1875 Henry Work visited the inn for a period of time and heard the strange tale of the haunted clock from the (then) publican, who was at that time, the grandson of the longest-living Jenkins brother. Some folk suggest this story is where the term, 'Grandfather Clock' originates from, as the narrative tells the story of his 'grandfather's clock', but this is not the case. The term was used many years prior to this. Work was so intrigued about this romantic tale that he decided to put pen to paper and write a song about it. It was a huge success.

There is an interesting ending to the tale. It is said that during the many years of its working life the clock never malfunctioned until *after* the death of the first Jenkins brother. During the clock's slow and eventual demise, it is believed that in the middle of one particular night the clock began to chime a 'strange-sounding and muffled alarm' for seemingly no reason, although the family firmly believed it was a warning of a forthcoming death in the family – the death of the other Jenkins brother. Soon after, the other brother

The song and music sheet for Henry C. Work's world-famous ditty, 'My Grandfather's Clock'.

The actual Jenkins brothers' 'long clock' or 'Grandfather's clock', known worldwide in the famous song.

The George Hotel in Piercebridge, near Darlington, where the fascinating tale of a clock that paranormally ceased working on the day its owner died can be found to this day.

did pass away, whereupon the clock suddenly and inexplicably ceased working too. As the song tells us, 'It stopped, short, never to go again, when the old man died'.

A coincidence? Was something really paranormal going on all those years ago at the George Hotel? If the clock was indeed haunted, then who was haunting it? A dead person? Personally, I don't think so. What interests me most, is the fact that the clock seemingly reacted to not just one man's death, but two. Somehow, for perhaps reasons not yet understood, the two brothers may have had an affinity or a bond with this clock – perhaps even a psychic connection they were unaware of – and through some unexplained means, as the brothers grew old and died, the clock did too. A further, yet spookier thought, is that the actual clock, an inanimate object, could have somehow had the affinity with the Jenkins brothers!

As ludicrous as it sounds, this could well be the explanation as to why the clock simply packed up and died. Of course sceptics would say ninety years is a very long time for a clock to keep working and must have simply packed up in a million to one chance coincidence on the day of the grandfather's death – touché. This does not explain, however, how it began to slow down and become a less unreliable clock after the *first* of the Jenkins brothers died. If this is a massive double coincidence, then it is the most amazing massive double coincidence I have ever heard of. To end the section I must offer a final possible explanation; that the entire tale was fabricated.

Whatever the truth behind the grandfather clock of the George Hotel in Piercebridge it has certainly left its mark on the paranormal world. In a modern and rational world that we now live in, the latter of these explanations is more likely to be accepted. Sad really, as the world needs to open up to the possibility of the paranormal because, believe me, the paranormal *is* a reality, restless ghosts *do* indeed walk, and poltergeists *do* indeed wreak havoc. Why shouldn't a psychic bond between someone and something exist?

Rolling Mills Steel Works, Darlington

A harrowing tale of a spectral sighting is told in Jack Hallam's book, *Ghosts of the North* (David and Charles, 1976). This ghost account is a well-attested and documented case because not one, not two, but *fifteen* witnesses saw the ghost that night back in July 1970. It began, Hallam says, when a 'blurred and transparent figure was seen in the finishing shop'. When it was approached, the figure was said to have groaned rather loudly and waved its arms around. One individual claimed to have thrown a brick at the ghost and then he and a large group of men watched this apparitional being disappear directly through a solid wall. A number of men then ran around to the other side of the wall to see if they could find this mysterious shape, but couldn't; not until they glanced up and saw it balancing precariously high on top of the wall.

Oddly, many years earlier, sometime in the 1920s, a former employee of the steel works was sadly killed along with four of his workmates during a tragic accident, when an overhead cable railway mechanism crashed down upon their heads. One of the dead men, during his tea breaks (when he was alive, of course), would climb up on the high wall and perform a number of acrobatic stunts and tricks, much to the amusement of the other workers. One day he fell off the wall and injured himself, putting pay to his acrobatic antics. Ever since the tragic day when those five men were killed, the area was reputed to have been haunted by a grey apparitional shape. It's clear to me that all those men back in the 1970s saw the tragic ghost of that young, daring acrobat back up on his favourite high wall performing his tricks – fifty years or so after his death!

Preston Hall Museum

The following section of this book is a slightly amended version of the history and paranormal events at Preston Hall Museum which first appeared in my 'Supernatural North' book (Amberley Publishing 2009). I have decided to reintroduce it into this volume simply because of the wonderful ghost tales and legends this particular locale has. Further, it falls within the boundaries of this particular book's geographical remit – just! In late 2007, fellow researcher Mike Hallowell and myself were contacted by a local charity, the Butterwick Children's Hospice, and asked if we were prepared to attend one of their many charity ghost investigations as 'guest speakers'.

The Butterwick Children's Hospice is a charity that provides care and support, free of charge, to children with life-limiting illnesses from birth to eighteen years of age, and supports their families. It provides day respite, end-of-life care, family support and bereavement care to families from Teesside, County Durham, North Yorkshire and Weardale. Skilled and experienced professional staff, along with trained volunteers, work in partnership with families and other professionals involved in each child's care. At the Butterwick Hospice, the focus is on each and every child enjoying their stay there while family members take a break from their round-the-clock caring responsibilities. In order to provide their free service to these families, they need to raise a staggering amount of money each year – something like £800,000 – and the ghost hunt night at Preston Hall was just one of many events the fundraisers like Diane Williamson organise.

The event was to take place in February 2008, so of course we agreed to appear for the charity and help out with the investigation in general. We were then told by the event organiser (Diane Williamson) that Richard Felix from Living television's *Most Haunted* was also making an appearance that night, and we would be sharing the stage with him. I was overjoyed at this prospect as I had long been an admirer of Richard Felix – even before his *Most Haunted* days – and I had always wanted to meet with him. In 2002, Richard had toured the UK in his quest for ghosts and produced his own video collection documenting his adventures. It is called 'The Ghost Tour of Great Britain – 2002', and he fashioned the videos by the UK counties and areas. I owned 'North East Ghosts' 'Derbyshire Ghosts', 'Yorkshire Ghosts' and many more and found them really enjoyable. Richard (in my eyes) was one of the few people that had a real interest, or a passion in something and had decided to do something with it. Out of his own pocket, he travelled the country doing what he loved to do and made something of his life. It is this reason that I respect Richard Felix and rate him as one of the UK's finest (and most enthusiastic, I might add) ghost hunters and this was also why I was so looking forward to meeting him. Now I had my chance, but not only was

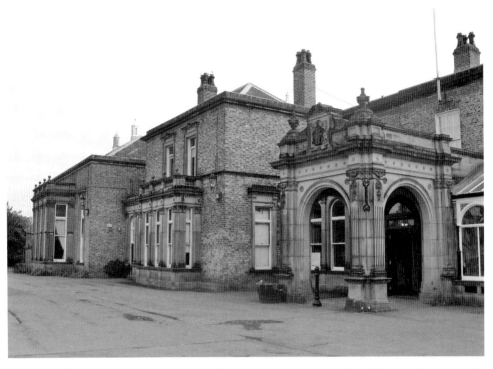

Preston Hall Museum, north of Eaglescliffe, was built in 1825 by David Burton Fowler and is home to a number of shades and spectres. The author carried out a talk on poltergeists here before taking part in a charity investigation. (*Picture courtesy of Rob Kirkup*)

I going to meet him, we were appearing together as guest speakers at the charity ghost hunt.

Preston Hall Museum is a Grade II listed building, located just north of Eaglescliffe, bordering County Durham and Teesside in 100 acres of land known as Preston Park. The hall itself was built in 1825 by David Burton Fowler and was sold by Matthew Fowler in 1882 to a local shipbuilder called Sir Robert Ropner or, to name him in full, Sir Emil Hugo Oscar Robert Ropner. Sir Robert Ropner was a Conservative MP named after his father who came to England from Magdeburg, Prussia, in the late 1800s. In 1904 Robert Ropner Jnr was given the title of 1st Baronet of Preston Hall. He died aged eighty-five in February 1924. The Ropner family resided at Preston Hall until 1937, and ten years later it fell into the hands of the Stockton on Tees district council. In 1953 it opened to the public as a museum. The museum includes many wonderful paintings including the *Dice Players* by Georges de la Tour, period rooms, a wonderful old toy collection, an armoury that includes some remarkable muskets and crossbows, and an incredible old-fashioned 1800s-style street with an old cobbled road, old lamp posts and authentic shops, business and even a police house.

During a pre-investigation tour of the building, a few weeks prior to the event, I was given some history of the ghosts and was told who the staff believe haunted the premises. The ghosts included a woman known as the Grey Lady that has been seen walking along the corridor on the upper level of the building.

The author with historian and television ghost hunter Richard Felix at Preston Hall Museum. Richard Felix also give a fascinating talk about his experiences into the paranormal.

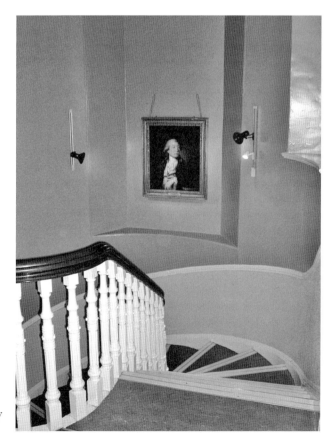

The stairwell at Preston Hall Museum where the ghost of a woman has been seen to silently make her way down.

She has also been seen by staff members as she floats down the main stairwell near the building's reception area, and continues into the main lobby before disappearing into thin air. Outside in the car park there is believed to be a ghost of a man dressed in black, on occasions seen wearing a tricorn hat. Believed to be a highwayman, this spectral being is said to be a harmless but nevertheless unnerving apparition and has been observed there countless times by the museum staff.

Other presences are said to reside in the building too, including a woman and her dog that has been seen in the dungeon area of the premises (which is now a display area for some of their ancient artefacts) and a sense of being watched by an invisible presence has been felt in the toy gallery. Up until this point in time, this particular building had never before been paranormally investigated by anyone and the ghost-hunting event that we carried out there was to be the first. It made local news with reporters from a selection of the north-east's tabloids being in attendance. If nobody knew about the museum's ghosts and spirits then, by golly they would soon.

During this first visit to the museum I made it my business to track down a few of the people that experienced paranormal activity. There were lots of staff on during our visit and it wasn't hard to find my first witness, so to speak. On reception there was a middle-aged gentleman who told me he had been working there for about five years and had indeed experienced some strange goings-on during his employment. On one of these occasions he told me that he had actually seen the spectral woman that haunts the upper corridor not long after he had started the job. Not being aware of the resident ghost, he thought she was just another member of staff, not realising until later on that the woman he saw along the corridor (which was from a distance and from the rear) was wearing odd clothing that was not their designated uniform. It was only when he discovered that there was no woman in the museum at that particular time (as it was closed to the public) that he realised that he may have experienced something paranormal.

Another staff member told me that on many occasions she would be in the area known as the 'toy gallery' when it suddenly becomes ice-cold for no apparent reason. 'A weird sense of presence then fills the room and a sense of being watched often followed,' she said. No one knows why this happens or what it could be. I was also informed that others have experienced the same sensations in there too. So, we could safely assume the building was indeed haunted. After spending a few hours in there, getting to know the place and mapping out the locations for the big night, we said our goodbyes to the staff and made our way home.

The night of the charity investigation (22 February 2008) soon came along and about 250 would-be ghost hunters turned up in their droves to see Richard, Mike and I do our talks and presentations before the main event. Richard began the evening by delighting the audience with some of his past paranormal experiences, his life as a ghost hunter and his theories on ghosts, poltergeists, and unexplained phenomena. We waited patiently at the back of the hall for Richard to finish off and it was soon our turn to take the stage. After an hour Richard answered many questions from the audience and then we were on. We spoke for just over thirty minutes and showed a DVD presentation. This was the first 'public showing' of the famous scratch footage we had filmed during the South Shields Poltergeist case in 2006. After our talk, we

were approached by Richard Felix, and many members of the public attending the ghost hunt and we were told just how incredible the DVD footage and our talk were. It appears our talk and presentation went down very well with most of the people attending, despite a few hiccups that occurred earlier on.

It was now time to crack on with the evening and the guests were split into teams. Five groups of eager ghost enthusiasts were soon ready to stake out the venue through the night being chaperoned by a local paranormal research team that were called in to help out. Mike and I (accompanied by fellow investigator Mark Winter) were 'vigil observers' so we could float in between the groups and work with whomever we wanted, whenever we wanted. If I have to be honest not a great deal of objective paranormal phenomena was documented which was to be expected. It goes without saying that a ghost vigil with over 250 people on it would not yield bona fide results that could be taken seriously due to the fact that controlled conditions would be nigh on impossible; having said that, it was only meant to be a charity fundraiser in the first place.

The evening, I have to say, went well and everyone had a terrific time in their vigil locations in search of the denizens of Preston Hall. Mike, Mark and I worked our way through the groups and spent time in all of the most paranormally active areas of the museum. Being 'vigil observers' and generally floating from team to team, we often found ourselves in areas of the building where no other team was working at that time and managed to get some quiet vigils under our belts, only to no avail. During one designated period throughout the course of the vigils, I managed to grab a lengthy chat with Richard Felix and found his enthusiasm for my South Shields Poltergeist case, and the paranormal in general, to be nothing short of exemplary. His passion and eagerness to learn more about ghosts and poltergeists is second to none and that certainly showed during our discussions. We chatted about Borley Rectory, and he regaled me with stories about when he spent the night in Borley in search of the phantom nun on 28 July 2006. He never saw the nun but informed me he saw a badger, something we both laughed about. Talking with Richard like this really was a great opportunity and it was something I had always wanted to do since hearing about his work with ghosts and the paranormal.

Before we knew it, the end of the night had come around and it was time to close down and finish the ghost night at Preston Hall Museum. The evening went rather well to say the least and I believe everyone present had a really good night. It was certainly an honour and a privilege to be asked by the Butterwick Children's Hospice to attend this charity night as a guest speaker with Mike, and Richard Felix; but it was more of an honour to help raise money for such a good cause, and to be able to meet the staff and people that have witnessed paranormal activity there first-hand for themselves, and glean some great accounts from them. To me, that is what it is all about.

29

Walworth Castle

In the admirable book, *Castles of Durham* (Frank Graham, 1979), Robert Hugill says that the 'lofty, ivy grown towers of Walworth Castle present an arresting sight to travellers along the by-road between Heighington and Piercebridge'. Indeed they do; he also goes on to say 'its situation is equally attractive, commanding a wide view of the broad and richly wooded vale of the trees'. This Grade I listed building, according to Hugill, was built by Thomas Jenison (although some suggest it was built by Thomas Holt *for* Thomas Jenison) in the closing years of the reign of Elizabeth I, which dates it to around the early 1600s making it one of the most up-to-date border strongholds. The first owners of this wonderful edifice, which is constructed with Limestone rubble and Welsh slate according to records, were a well-to-do family related by marriage to the Nevilles of Raby Castle. They were known as the Hansards, but Hugill suggests they may have been called Halsart. For the purpose of this book we shall use the more commonly accepted name: Hansard.

It is thought that the present building stands on the site of a far older manor house built by the Hansard family way back in 1150. During the Black Death in 1349 this original building fell into the hands of the Neville family but was eventually reclaimed by the Hansard family around fifty years later in the early 1390s. After his death in 1395, Robert Hansard passed the castle down to his son – Sir Richard Hansard – who in turn passed it down to his son, Richard, in 1454. This 'passing down' of the castle occurred time and time again with the building subsequently remaining with the Hansards until 1539, when the family line eventually came to an end with an heiress, 'as often happened in such families' as Hugill puts it. When she married Sir Francis Ayscough the castle subsequently

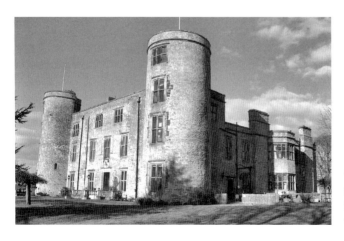

The impressive Walworth Castle in the rolling hills of County Durham is racked with ghost tales and legend.

became the Ayscough seat, but as that family also had no more heirs, it was eventually sold to the aforementioned Thomas Jenison. One presumes the older building then, that Jenison had just purchased, was subsequently knocked down with the new present castle being built by Thomas Holt, for Jenison, at this time, towards the end of the 1500s.

The castle stayed with the Jenisons until 1759, whereupon it was sold to one Matthew Stephenson – a wine merchant – and then on to John Harrison in 1775. The castle was subsequently passed down to many different owners for many more years. During the Second World War, while the castle was in the hands of its final private owners – Neville and Charles Eade – it was used as a POW camp for 200 German and Italian prisoners of war. Eleven years after the war, in 1956, it was purchased by Durham Education Authority and became a residential school for children; it remained a school until at least 1979. In 1981 the castle became a hotel and has been one ever since. Over the last thirty-one years since this transition, it has seen a number of different proprietors with the most recent being Rachel and Chris Swain, who carried out brand new renovations to the building between 2000 and 2006. I will end this brief historical introduction to Walworth Castle with a quote from Robert Hugill. In his aforementioned book, *Castles of Durham*, he states that, 'Walworth has experienced little, if anything, of the border wars; and the Civil War, which reduced so many strongholds to ruins, seems to have passed it by. Probably the most memorable occasion in its history was the visit of King James VI of Scotland in the course of his journey southward for his coronation as King of England.'

That's the history, now the mystery. The castle is reputed to be awash with ghosts and phantoms, with many legends attached to the building. Some folk have suggested that these ghost tales are somewhat 'imaginative'; the suggestion has also been made that the hotel business takes advantage of these stories at Halloween (it is not stated if this refers to the present owners, or past hoteliers). To the serious ghost hunter, at a first glance this sounds quite portentous but we have to consider the fact that these things are said in relation to most places that claim to have ghosts. Just because some ghost stories can be made up – and sadly, some *are* made up – does not mean that *all* of them are. In my opinion these ghost tales *must* have originated from somewhere. No matter how far we dig to uncover certain truths about 'alleged events' there is, in nearly all cases, that element of truth that can be found to back up or substantiate the story. Whether or not there is any justification to say the ghosts of Walworth are nothing but fiction, or 'imaginative', is a question that I personally cannot simply answer.

Let us now take a look at a few of the ghosts that this beautiful hotel allegedly has. Author and paranormal investigator Rob Kirkup says in his book, *Ghostly County Durham* (The History Press 2010), 'it appears that over eight hundred years of history have left a lasting impression on the building, as ever since the hotel first opened its doors ghostly happenings have been commonplace'. Now this statement is intriguing and it suggests that there have been no ghost sightings at Walworth Castle *until* it became hotel, which is somewhat curious. Sceptics might argue that to drum up business for a new hotel there is no better way than to give it a ghost.

Anyway, the first ghost is that of the phantom maidservant. This maid, it is alleged, had a long and secret love affair with one of the lords of the manor and consequently became pregnant. The lord of the manor, whose name seems to elude everyone, was said to have been enraged about the predicament he found himself in and was deeply concerned about

what people would say if they were to become aware of his sordid little secret. What should he do? Well, at the time he was having some work carried out within the castle and this gave him the motivation to commit murder most foul. Without guilt, shame or even a second thought for the poor woman *and* her unborn child, he lured her into an aperture behind a thick stone wall and, it is said, walled her up alive. As you would expect, she was said to have been completely petrified as she watched in horror, the only exit being slowly blocked up, moment by moment, brick by brick. As each block was added, it slowly diminished the daylight until the last block was positioned and cemented in place, throwing her into eternal darkness. Goodness knows what she must have been thinking at this particular time, knowing that she was now going experience a slow and dark, painful death and there was not a damn thing she could do about it. Rob Kirkup says, 'She was absolutely frantic, unable to see or move, screaming out for help and scratching at the walls in vain. Although her screams of terror would have undoubtedly been heard, no one came to her aid. It is unknown how long it took for her to die, but she, along with her unborn child, died behind that wall and her spirit remains at Walworth Castle to this day.' By all accounts her phantom footfalls can be heard pacing up and down a spiral staircase that no longer exists, the staircase in question being in the same area she met her painful and dark demise in. She has also been seen – allegedly – in guest rooms throughout the hotel/castle by startled guests after waking up to find her standing over them; a most harrowing thought indeed.

Walworth's other infamous ghost is said to be that of Ralph Jenison who lived at the castle for fifty years or so after it was bequeathed to him at the young age of ten. It is said that Ralph, in a moment of complete insanity, pulled out a gun and blasted his brother in the chest after a silly argument. His brother, bleeding profusely from a gaping wound, was taken to the room that is now believed to be room 17 and laid down. Efforts were made by Ralph to save his brother's life but they were in vain; his brother died soon after. You would have thought that the ghost of Ralph's brother would have been the candidate for the castle spook but it was not to be. Instead, when Ralph passed away in 1759, it was *his* spectral form that was said to come back and haunt the castle. He was never able to forgive himself for what he did to his brother, his lost and sad soul forever remaining at Walworth, perhaps seeking forgiveness for his act of foolishness. This is ironic really because *after* Ralph had died, his widow was forced into to selling the castle due to debts incurred from his renovations and lifestyle during his time there; so he stayed, and she went!

Other areas of the castle are said to be 'infected' with spiritual activity too, including the Jenison Suite, where a member of staff was once horrified to see a small wooden dresser move on its own across the room and come to a standstill in front of the room door, essentially trapping her *inside* the room. The castle dungeons or the hotels basement is also said to be plagued with the paranormal; unexplained noises being heard by staff when no one is down there. When they *do* venture down to investigate, they are often pushed around and touched by 'unseen hands'; a common facet in a lot of hauntings.

So, is the castle at Walworth haunted? Do the phantoms of long-deceased individuals still walk the corridors at night, making strange and eerie noises in the process? I think it is likely; however, I have informed you, the reader, of the alleged sightings, the history (paranormal and otherwise) regarding this wonderful old place, and I guess you'll have to make your own minds up about Walworth itself; and indeed all the rest of the accounts contained within this book.

High Rigg House Farm, Weardale

On the rolling hills in the Weardale area of County Durham, overlooking the small village of St John's Chapel, stands an old desolate farmhouse. This farmhouse has, by all accounts, stood on the same spot for over 400 years, making it one of the oldest and most historic buildings in the area. Of course, standing there for 400 years you would expect it to have seen a lot of people come and go, and it also would have borne witness to lot of other activities occurring in and around the area. Sadly, not too much is known about the history of this old farmhouse but I have managed to glean a little information from its present owner; one Kenneth Madison, which I will relay to you shortly.

Karen Lindsey, a relation of Kenneth, who lives in Sunderland, often visits the beauty salon which a very good friend of mine, a Sunderland-based paranormal investigator called Fiona Vipond, co-owns and runs. During one of her many visits there the ladies were, as usual, engrossed in chat when the subject of ghosts came up. Fiona showed great interest and explained she was a ghost enthusiast. It wasn't long before she was informed about the strange goings-on at the desolate High Rigg House Farm. She subsequently got an invite to go and see the farm and maybe spend the night there and within a week or so she had it all arranged. The Ghosts and Hauntings Overnight Surveillance Team were set to go and investigate the premises, and on 12 November 2011 we carried out the investigation.

We arrived at St John's Chapel in Bishop Auckland at 9.00 p.m. and were met down in the village by the farm owner, Kenneth. From there we made our way up a country road and arrived at the farmhouse within plenty of time to get set up and prepare for the investigation to come. The first thing that I wanted to do at this point was talk to Kenneth about his farm and about the paranormal experiences that he claims to have had there. Kenneth has lived there since around 2007 and is currently (at the time of writing) renovating the premises and restoring the interior back to its former glory. He tells me that the building began its life as a coaching inn or a public house; or at least that is what he said the village locals think. Over its long and varied past the house has also served as a private dwelling for a number of families and individuals; including a local witch by all accounts, and has even been a one-time refuge and sanctuary for ill and sick animals and for other animals that have been destined for 'exploitation and slaughter'.

Since moving to the property back in 2007, Kenneth has claimed to have seen two apparitions and experienced other bewildering forms of paranormal phenomena. Kenneth told me he had seen a hooded figure which he thought, at first, was a woman,

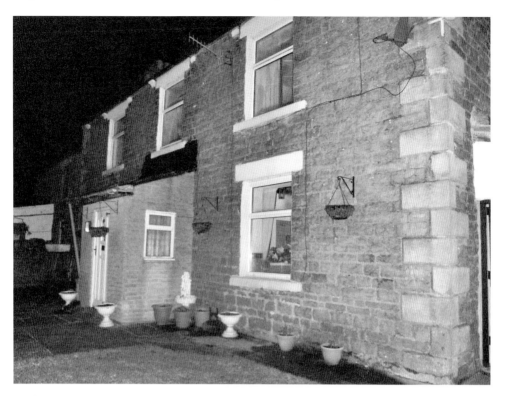

High Rigg House Farm at St John's Chapel, Bishop Auckland; taken on the night of the author's investigation there in November 2011.

but is now convinced that this figure was in actual fact a monk. His second sighting occurred about a week later on the stairwell outside a room now known as the 'witches' bedroom'.

After getting out of bed to pay a visit to the lavatory in the early hours of the morning he was surprised to see the figure of a 'man of the cloth' dressed in full regalia. Kenneth describes him as 'pope-like' and to this day, still refers to this ghost as 'the pope', although he is fully aware that the spectre is highly unlikely to be a former head of the Catholic Church. Subsequent inquiries have led Kenneth to believe the figure he saw in his house was that of a bishop or a cardinal. Kenneth was a very sceptical individual until he saw these apparitions and now believes entirely in the existence of ghosts. Up until that point in his life, however, he never gave the paranormal a second thought and saw his ethereal visitors at time when he least expected to.

Other things have occurred in the house too, and strangely all connected with the doors or doorways. Quite often, doors that are closed are found wide open, and when they are left open, they close on their own. Kenneth has seen this occur with his own eyes and after I spent some time in the house one night back in November 2011 with Drew Bartley and Fiona Vipond, we did too. 'Sometimes, the doors rattle and shake, as though someone is behind them trying to get in,' Kenneth told me.

Incidentally, in the two upstairs bedrooms there are security chains which are usually found on the inside of exterior front doors to prevent the door opening fully. I asked

An artist's representation of the phantom cardinal or priest seen by Kenneth Madison at High Rigg House Farm. (*Picture courtesy of Drew Bartley*)

The actual spot in High Rigg House Farm where Kenneth saw his ghost. It stood under the arch at the top of the stairs and stared intently at him for a few minutes before vanishing into thin air.

Kenneth why there were chains for the doors on the inside of his bedrooms and he told me 'I have no idea ... they were there when I moved in, and I have not got round to remove them yet'. Fair enough, but I began thinking: why would someone have locks and chains on the inside of the bedrooms? The only answer I could come up with was that at some time, the past tenants obviously wanted to keep someone – or something – out.

The thought occurred that they too were haunted while living in this building and decided that, because the bedroom was such a personal and private place, a room for rest and recuperation, they perhaps naïvely placed the security chains on the doors to prevent any unwelcome night-time visitors – albeit otherworldly – from entering their rooms during their slumbers. Of course you would think that any ghost or spirit could simply walk *through* the door or even the wall and enter the bedroom with no problem therefore fitting locks would seemingly be a waste of time. Unless we consider the fact that these spirits may not know that they are, in actual fact, dead! Think about it: imagine that you are now deceased and you have become a ghost. Now imagine that you think you are still alive. To walk through a closed door rather than open it is a ludicrous suggestion, isn't it? People that are alive and still in the physical don't just walk through closed doors. Therefore we would try and open it normally, like we always do. If it won't open, then we soon give up; maybe the ghosts here do the same? Having said that when a ghost does seemingly walk through a solid brick wall it is because at one time in the past, a real doorway aperture once stood at that very point. The theory being the ghost is walking through the door in 'its' time, but a wall in the present time; a little food for thought, there.

Anyway, one night, when Kenneth was in his bed, he woke up to hear the sound of these chains being rattled and noticed the door was shaking violently. Knowing no one else was in the house with him at the time, he simply ignored it until the noises ceased, and then went back to sleep. When he woke up in the morning, all was well and there were no signs of any flesh-and-blood intruders. When he was telling us about this strange account he showed Drew, Fiona and I the very security chains that prompted me to ask why they were there in the first place.

Kenneth then told us a number of other strange and eerie occurrences that have happened at the house over the years; one was quite chilling and involved the discovery of what Kenneth describes as human fingers. 'When I first moved in I went down into the cellar and found a little passage area that was not yet bricked up so I began to dig it up in an effort to clean it out. During my digging in the cellar I came across some bone fragments which to me looked like human fingers. One of the bones was almost a full finger and was complete with knuckle joint. At this point I became a little unnerved and stopped digging and I have never returned to it.' I asked Kenneth if he still had any of the bones anywhere in the house and he said that he did. Kenneth showed us some of the bones which I have to admit made me baulk somewhat. If these were real bones, and belonged to a real human being, then why were they buried in the cellar? A point we will come back to real soon.

The second interesting incident was the mysterious appearance of two gold wedding rings that had never been seen before by Kenneth or his family prior to that point. The first ring, the man's wedding ring, appeared exactly one week before the lady's wedding

Drew Bartley holding the remains of what Kenneth believes to be a human finger that was found at his house while digging out the cellar. Drew is not convinced, but the author remains open-minded.

Apports; these two wedding rings, within the space of one week of one another, mysteriously appeared at High Rigg House Farm and were subsequently found by Kenneth. He has no idea who they belong to as he has hitherto never seen them before.

ring appeared. It has remained a mystery to this day where they came from. They now sit on Kenneth's stone mantelpiece over the roaring log fire to this day.

Because of the reputation his house was getting through the strange occurrences, his family and friends became weary about visiting. One family friend of Kenneth's called Joan will visit the house and stay over but her husband refuses to. He insists on staying in the village bed and breakfast because he is so frightened to spend time in the house. Because of this, and all the other aforementioned accounts, it was decided that a team of mediums should visit the house to determine just what was going on. This was subsequently arranged.

During this visit one of the mediums told Kenneth that the house was once lived in by a witch and had built up a vast amount of literature and books on her chosen craft which remained in the house until her death. The medium told Kenneth that he was 'in contact' with this dead witch (during his visit) and that she subsequently informed him that she was very annoyed because her beloved books had been removed from the house at some point and she wanted them back. As it transpires, Kenneth did indeed find dozens of old historic tomes and other literature on witchcraft *after* he moved in but subsequently got rid of the entire collection thinking of it as nothing more than clutter – much to the dismay of the author! The medium, according to Kenneth, was actually unaware of any books at this point and was also completely unaware that Kenneth had indeed removed them from the house. This fascinates me, in all honesty; a great example of when an alleged medium comes up with facts and information that they could not have known previously. To me, it adds to the credibility of the haunting and further supports the theory that *some* mediums (not all, I hasten to add) may indeed be genuine.

The medium then went on to tell Kenneth that a room at the back of the house was used by the witch. From the window you can see the desolate hilltop and allegedly the very spot where other so-called witches were said to have been burned alive. It is said that the witch lived in that room and watched the burnings taking place. This troubled me at first because I always thought that in England witches were not burned, but hanged. However, in *Folklore, Myths and Legends of Britain* (*Reader's Digest*, 1973) it clearly states that there were a number of burnings of witches that *did* take place in England before the law was abolished. Was one of these burnings here at County Durham? I guess we will never know for certain, but I think it's highly unlikely.

The medium had also suggested that this witch had accidentally killed two of her children after administering potions and remedies in an effort to rid them of some ailments they were suffering from. This brings me back to the bones that Kenneth found under his house. If the medium's testimony is correct, then perhaps these bones were the remains of the witch's children? It's a tantalising thought but I think that before we go any further in making assumptions and jumping to conclusions, the bone fragments in question must be examined in a professional capacity and verified as human. Carbon dating the bones should then be the next step to tell us how old they are. Team member Drew is convinced they are bones of an animal and *not* human finger bones at all. Having worked in radiology for many years I think he would recognise a finger bone when he saw one. To end the reading the medium told Kenneth that he picked up on both the apparitions in the upper level of the house, the monk and the bishop. This was

all Kenneth could tell us about the mediums visits and the paranormal activity that he had experienced there; it was enough to go on and we were now that little bit more informed and therefore better prepared to investigate his house.

It was at this point in the proceedings – at about 10.00 p.m. – that Drew went upstairs to do some filming for the investigation DVD which is always made after our visits. After ten minutes or so he came downstairs and was rather perplexed to say the very least. He asked Kenneth about the door that leads into one of the main bedrooms on the upper level of the building. He wanted to know if it closed on its own. He asked this because as he entered the room – the door being already wide open – he turned around and commenced filming only to see the door being pushed closed by what were seemingly invisible hands. On the tape you can clearly see the door begin to close with speed until it was almost closed completely.

Drew is adamant that he never made contact with the door on his way in to the room, indeed this can be verified when one looks at the footage. Kenneth told him that the door does not normally close on its own; indeed, further tests to try and get the door to close to the same degree of speed that it did earlier, by both Drew and me, proved fruitless. We nudged it, pushed it, and walked past it, all to no avail. It wouldn't move. What closed that door when Drew was in the room is anyone's guess, but we know it didn't close naturally

Now, interestingly, *before* Drew ventured up the stairs he nipped into living room two with his film camera. This is the room at the foot of the stairwell and is a room that is fully decorated and furnished, but never used. After Drew had filmed some shots in there, he pulled the door shut and made his way upstairs to the main bedrooms. On his way back down to report the bedroom door opening – which he filmed – he also noticed that the door to living room two was now wide open. Since Fiona and I were in living room one, we know for certain no one had left the room and ventured into living room two. When he came through into living room one, Drew then told us about *both* doors. We then set about testing the doors to see if they could somehow swing on their hinges on their own and in a natural way, but we could not work out on this occasion how this could have been done. We closed the downstairs door once more and waited in the living room opposite to see if it would mysteriously open again, and it did!

We then discussed the idea that the wind or draught that was created from closing the first door could have been enough to push the second door open. Of course we then tried this immediately by pulling the door closed hard thinking that we would then find door two open, but it remained shut! We tried again, to no avail. A video camera was placed at the bottom of the stairs facing the door to see if, once again, we could catch a door moving on its own. If that door often blew open or fell open in a natural way after it had been closed properly in its aperture, the likelihood was that it would happen again soon. The camera was left there for a few hours and the door refused to open on its own again; just what we suspected! A further thought occurs: naturally occurring things don't just stop when you train a video camera on them, but as experience shows, *most* paranormal ones most certainly do.

This was illustrated nicely after the video camera was taken away from the bottom of the aforementioned stairwell. No less than ten minutes after, at 10.25 p.m., when the area was *not* under video surveillance, a bell rope that was hanging down from a

The door that closed on its own and was filmed by investigator Drew Bartley.

large bell hung on the wall outside this room was found to be swinging violently, as though an attempt had been made by someone or something to ring it! I was standing at the top of the stairs with Fiona Vipond when this startling discovery was made and no one was at the foot of the stairs. If the video camera that was originally trained on the door was still in position, it would have most certainly caught the bell rope as it *began* to move on its own. We do have footage of the bell rope moving back and forth but this was recorded after it had started to move which, in all honesty, is no good at all as objective evidence! Is it possible that there was an intelligent force at work here making sure we did not get any good objective evidence or footage? Frustrating as it is, and whatever the cause, there was not a damn thing we could do about it, so it's up to you, the reader, to decide if what I tell you is indeed the truth or not. However, the six people in that house at that time *know* it is the truth. This all happened incidentally, before the actual night vigils began.

When the night vigils did begin after an extensive baseline test, very little paranormal or unexplained activity was documented although there were two or three occurrences that manifested between the hours of 11.00 p.m. and 4.30 a.m. that are indeed worthy of note. Early on in the investigation Drew Bartley reported that he was pushed in the stomach by something as he was calling out to the atmosphere. He said that it felt as though two or three fingers were gently prodding him in the stomach and cannot explain it to this day. Fiona, during one of her vigils, had her coat hood pulled off her head by unseen hands. She was rather cold at this point and therefore put up her hood. When it was pulled off, it gave her a bit of a fright as you would expect. Finally, during the vigils at around 4.00 a.m. when we were all standing at the top of the stairs, suddenly, and from nowhere came the overwhelming stench of cat food, which everyone could clearly smell. It was as though a tin had been opened and held right up in front of our faces, it really was that strong. There are no cats living at this house presently so we are at a loss to explain this. We were told, however, by Kenneth, that the resident before him was a cat lover and owned over a dozen cats at one time, although why the aroma of cat food should manifest itself paranormally is anyone's guess.

The night vigils came to an end and it was during the packing-up phase when I experienced my final odd occurrence of the night. When I was in the kitchen area I was placing some equipment into my bag and had my back towards the door that led into an outhouse area, which in turn led outside. I suddenly became aware of footfalls and some thumping noises coming from this outhouse area as though there was someone either inside trying to get out, or outside trying to get in. The noises were so loud that I actually thought there *was* someone there. I ventured in, half expecting to see someone, anyone, but was surprised to find no one. I walked through the outhouse and across to the door and peered outside into the early morning darkness and again, no one was there. I then hurriedly made my way back inside and explained what I had just heard, to which Drew Bartley replied, 'Yes, I just heard them noises too ... I also heard them earlier on as well, but when I looked outside there was no one there.'

High Rigg House Farm really is an abode with paranormal mystery and a blurred and unsure history. Fortunately, there is a lot more opportunity for the author and the Ghosts and Hauntings Overnight Surveillance Team as we have been invited back to reinvestigate the premises. This is a wonderful prospect for the team as it gives us a

chance to spend many more hours partaking in vigils and attempting to secure that very sought-after piece of objective and convincing evidence that all ghost hunters are searching for. A lot more can be learned from this particular venue as we all feel the house has a lot more to offer in the way of its history, and of course it's ghostly or paranormal activity. It was an immense pleasure to spend time in this most historic and essentially unknown location and I am sure I speak for the rest of the team when I say 'we cannot wait to go back'; watch this space.

The rope on this bell was found swinging rather violently by the author and verified by fellow investigator Fiona Vipond. We think an effort was made by one of the spirits in High Rigg House Farm to actually ring the bell; why it would want to, or why it never managed to, we don't know.

Barnard Castle

The magnificent old ruined fortress known as Barnard Castle is situated in the ancient town of the same name. The bastion came first when it was founded by the Normans shortly after the Conquest, with the town, which took its name *from* the castle subsequently growing and developing around it. This one-time home of Bernard de Balliol during the twelfth century is now a Grade I listed building; well, at least the remains are. The chapel building on the same site is actually a Grade II listed edifice. Standing proudly on a huge clifftop overlooking the River Tees the ruin certainly is a wonderful sight to behold.

The history of Barnard Castle is a most fascinating one to say the least. It has been laid siege to on a number of occasions with many people having died in and around the castle area. The most notable sieges took place in 1536 and in 1569. The latter of these sieges occurred during the Rising of the North, which was a reprehensible plan hatched at nearby Raby Castle. The 'rising' was essentially a plot to rid the country of the reigning Queen of England Elizabeth I and substitute her with Mary Queen of Scots. For eleven days and nights the castle was laid siege to by supporters of the Scottish queen, but it was bravely defended by Sir George Bowes. Sir George's eleven-day resistance proved costly for the rising as it gave time for the relevant authorities to assemble their forces and defeat the rebellion; although the rebels did eventually take the castle, it was to be alas, all in vain.

The sieges had a detrimental effect upon the castle and, damaged to quite a large extent, it was sadly never restored. In 1630 the castle was purchased by Sir Henry Vane, who by this time also owned the aforementioned Raby Castle. Due to Vane residing at Raby Castle he transferred a lot of the old stone and brickwork from Barnard Castle to his primary residence where it was subsequently used for additions and repairs. Barnard Castle was now destined to decay and rot and, by the end of the eighteenth century, it was nothing more than an unused and empty shell. It is now open to the public and is looked after and cared for by English Heritage. It is a magnificent reminder of the turbulent times gone by.

There is said to be only one reported ghost here at Barnard Castle, but one is all that is required to qualify for inclusion in this volume. The alleged ghost is said to be that of a spectral woman and is called – according to a medium's testimony – Lady Ann Day. Little is known about the life of this woman but it is *thought* she lived in the sixteenth century and was killed at the castle after being thrown over the walls down into the River Tees some 200 feet below the castle. Rob Kirkup, the author of an admirable book to which I wrote the foreword, *Ghostly County Durham* (The History Press,

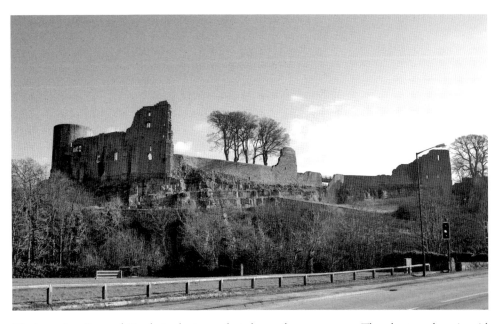

The imposing Barnard Castle in the town that shares the same name. The phantom here is said to be a lady who was thought to have lived in the sixteenth century. Legend has it she was killed after being thrown over the walls down into the River Tees some 200 feet below.

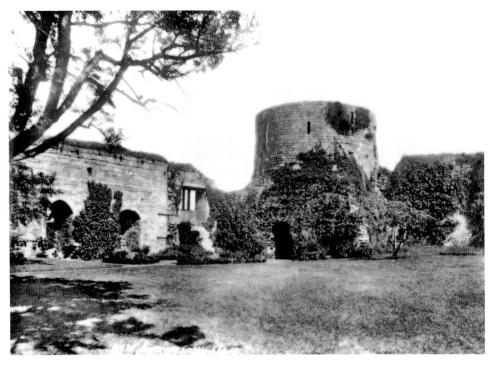

The circular turret from inside Barnard Castle *c.* 1920. (*Picture courtesy of Newcastle Libraries and Information Service*)

2010) says that 'hundreds of horrified visitors to the castle have witnessed a woman, dressed all in white, fall from the castle; some have claimed that the fall is accompanied by her scream, but just as the woman appears to hit the water, there is no splash, it's as if she just vanishes'.

A fascinating story but sadly a tale that cannot be verified; or can it? According to Kirkup, 'hundreds of visitors' have seen this ghost as she falls from the castle and disappears before hitting the river. Kirkup doesn't say *when* these witnesses saw the ghosts so who are these witnesses, are they still alive today, and can they verify or at least provide some written testimony to what they saw? Could they shed more light on the ghost itself, or maybe even help to describe her in more detail which could in turn help verify who she really is? If you are reading this and you know someone that has seen her then do drop me a line and tell me all about it; I would love to hear from you.

Phantom Horses and Ghost Riders of County Durham

One of the most spine-chilling ghost accounts you can get, in my opinion, is that of the headless horseman, and there are many blood curdling tales to tell about them. Some folk may scoff or ridicule the notion of phantom riders galloping furiously along lonely stretches of roads mounted firmly upon the backs of their trusty steeds after darkness has fallen, but let me tell you, there is a larger assortment of truly terrifying accounts in the UK than you would often care to think. What is more, a creepy collection of these spectral stallions and riders have been seen right here in Durham County. There are a few offhand that I can think of, so we will discuss these in this section.

The Staindrop Spectre

In Staindrop, close to Raby Castle, a bloodstained rider galloping on a white horse is said to cross the meadows, fields and old roads. Legend has it that his spectral form has been seen not only thundering across the moors, but also disappearing into a hillside like a grey lady through a wall. No one knows why this spectre should disappear into the ground like it does but the author makes a suggestion in the next section which we will look at presently.

The Phantom Rider of Hamsterley Forest

In West Auckland, there is another phantom horseman that has been seen galloping at speed towards Hamsterley Forest. Once the rider enters the forest, it is said he disappears without a trace. Just who are these phantom horse riders and why do they seem to always gallop across hilltops and countryside. One possibility is that they are the ghosts of highwaymen. This may make some sense as both of the aforementioned ghost tales end with the horse and their riders disappearing from view and heading into a place that could been described as a hideout. The Staindrop ghost vanishes into the ground where once and entrance to a cave *might* have been where booty and ill-gotten gains *could* have been hidden after certain raids. Likewise with the rider disappearing into Hamsterley Forest; perhaps after raids this horseman hid deep in the forest? Highwaymen were all too commonplace in centuries gone by – most notably the 1700s and 1800s – although the majority of highwaymen you hear about worked the roads down south, there are *some* famous instances of highwaymen in Yorkshire, Tyneside, Durham and Northumberland.

An artist's representation of a phantom highwayman as he gallops on his horse. Could former highwaymen be responsible for many of the ghost sightings in and around County Durham? The author thinks that it's plausible. (*Picture courtesy of Julie Olley*)

Earlier in this book I talk about a phantom highwayman that is said to reside at Preston Hall Museum; if the reader can recall, I say, 'outside in the car park there is believed to be a ghost of a man dressed in black, and on occasions seen wearing a tricorn hat. Believed to be a highwayman, this spectral being is said to be a harmless but nevertheless unnerving apparition'. Who's to say there were not any more working the areas of Durham and somehow, after death, they still roam the land atop of their trusty steeds, forever in search of coaches to rob, women to woo, and treasures to obtain? Plausible theories and one must remember this is all they are, theories.

The North Pennine Moors Ghost

A sinister tale of alleged murder leads us into our next ghost story, which begins in around the year 1800. It is said that, after tending to some business in the three villages of Allendale, Alston and Nenthead, a tax collector began to make his way home to Teesdale which meant a long and hard trek of over 30 miles on horseback over barren wasteland and moors. The story goes that the taxman reached an area known as Park House Pasture, whereupon he – and his enormous amount of takings – suddenly disappeared without a trace. Soon after, three local men were suspected of his murder although nothing could be proved beyond all doubt. The suspicions were first aroused

by villagers when one of the men in question was seen to push a horse down an old mineshaft. Combine this with the fact that these three men suddenly became very well-heeled, and it doesn't take a genius in this respect to put two and two together and actually come up with four. As frustrating as it was for the villagers, nothing could be done about it and before long everyone was getting back on with their normal lives.

Many years elapsed and the murder of the taxman had almost been forgotten until one fateful night in 1849, nearly half of a century later, when the skeletal remains of a body were found buried in a quarry. A new road was being made in the area where the taxman had been seen last and it was due to these new road works that the skeleton was unearthed. Word soon got around the local villages that the remains of a human had been found and it was not long before the memories of the missing taxman came flooding back – to those that could remember it, of course. Obviously, everyone then jumped to the conclusion that this must have been the missing tax collector that had disappeared all those years ago. Suddenly, a spate of ghostly sightings began to occur on the lonely moors. People would say that they had seen a phantom black horse and a spectral rider making its way across the hilltops. More harrowingly, this apparition was seen to canter toward the quarry edge and continue to gallop straight over the edge of the cliff – to exactly where, incidentally, they say the skeletal remains were found. People became so terrified of the apparition on the moors they simply refused to venture out on the new road after dark.

Every few years, and always on the same date, coinciding with the day that the body was discovered, it is said the phantom rider makes an appearance. The last documented sighting was back in 1973; one year after the author was born. You may be wondering just when this particular night is? Well, you will not be surprised to discover it is on the one night of the year where they say the veil between this world and the next is at its thinnest: 31 October.

Langley Old Hall Ruin

Situated on a grassy hillock lying on the outskirts of Durham City, and looking over the River Browney, is one of Durham's most fascinating ruin. Very little remains of Langley Old Hall now, with only one single curtain wall overgrown with trees and bushes remaining. It is a very dangerous area to be in due to the fact these old ruins are on the brink of collapse, so my advice is please do not go snooping around there in case you end up becoming what you are looking for – in that respect I mean a ghost! According to local historians, this one-time family home, which was said to be more like a castle than a hall, was linked to members of the powerful Scrope family. They remained there, by all accounts, until the hall fell into a serious state of disrepair in the 1750s. The site of the house has remained in this very unstable condition since.

A lengthy gravel drive festooned with trees on either side of it was said to have led from the main gates to the house and it was on this gravel drive that the phantom horses have been seen and heard. Witnessed by an abundance of people, this collection of spectral stallions, dragging along a ghost-like coach, has been spotted as it thunders towards the old ruined hall. The horses – four, by all accounts – are said to be black

with some folk suggesting they are headless. When the phantom coach and four reach their destination, which is at the top of the drive, it disappears into the ether leaving the surrounding area in an uncanny state of eerie silence. Occasionally, it is only the spine-chilling *sound* of the wheels crunching across the gravel drive accompanied by the horses galloping.

South Street, Durham City

Another tale concerning phantom horses is centred on South Street in Durham city. In actual fact, the ghost that is said to haunt this neck of the woods is none other than the 3rd Earl of Derwentwater, otherwise known as James Radcliffe. James Radcliffe lived in Dilston Castle in Northumberland but died in London after the role he played in the failed Jacobite rising of 1715 against George I. Once his head had been removed from his body, both parts (his head and body) were brought back up to Northumbria and given a proper burial at his family seat at Dilston. It was *then* when the good folk of Durham city began to see the headless spectre of the Earl as he thundered down South Street on a phantom coach. No one knows why the Earl haunts the old cobbled lane which stands opposite the great cathedral, but a recent hypothesis suggests it may be because his sister – one Lady M. Radcliffe – once lived not far away in Old Elvet. Perhaps the earl frequented this area on his way to see his sister during trips to Durham taking the route of South Street on the way, which could be why this spectre is returning there after his death.

South Street in Durham city; another locale for spectral horses.

Tales from a Durham Historian

During the course of my ghost hunting career I have met many folk and spoken to them all in detail about ghost-lore, myths, legends and the like. This is one of the many perks of the job, I suppose. Not only do I visit what seems to be a never-ending list of a variety of haunted places, and go in search of the actual ghosts for myself, I have the added pleasure of meeting new people *from* these particular places and then finding out *new* ghost tales and stories at the same time. More often than not, I often go looking for one particular ghost, and end up coming away with a wealth of tales from others, which has an immense additional benefit! As I was researching the tales of County Durham for this volume, I came across a website owned by a paranormal historian and ghost hunter going by the name of C. J. Linton. Not only did I find what I was looking for on his website – which was verification regarding some information – I also discovered a whole plethora of ghost accounts of which hitherto I was completely unaware. I decided to contact Mr Linton immediately and ask him if he was prepared to share some of his wonderful research – along with some of his own unearthed tales of the supernatural – with me for this book and, ultimately, with you, the reader. Happily, he most kindly obliged.

I am sad to say that I had never heard of Christopher John Linton prior to the researching of this book but had I not been conducting research *for* this very book project, the likelihood is, is that I may not have come across him at all. C. J. Linton's website (which can be found at www.freewebs.com/paranormalhistory/) is a mine of information. The visitor can log on and enjoy a remarkable number of ghost tales and legends that are centred on his native South Co. Durham. This is probably one of the most detailed and thorough websites devoted to the paranormal history and paranormal encounters of this area and I implore the ghost hunter/historian/reader to get online and take a look. I was pleasantly surprised to learn what I did from it. As previously mentioned I have been given special permission by C. J. Linton to access his work and reproduce verbatim certain sections for this book and for this I am indebted to him.

Mr Linton begins:

I live in the south of County Durham, just a stone's throw from North Yorkshire in fact. More specifically I live in Newton Aycliffe, a new town developed in the '50s and '60s, making use of the massive Industrial Estate which was used extensively throughout the Second World War as munitions works, Aycliffe was chosen mainly because of the number of days in which there is cloud cover and fog – something which hasn't changed since the Second World War. Local legends abound however ... within Newton Aycliffe itself there are many ghost stories. I had an advert in the local

newspaper a while ago for people to tell me their ghost stories and it blew me away how many people contacted me. The vast majority of Newton Aycliffe was built on old farming land. Some of these old farms remain but some houses built on nothing more than dark soil have acquired a ghostly reputation. A local taxi driver told me of the hauntings within his house; a man dressed in riding boots, dark cape and red shirt has been seen by him [the taxi driver] and his wife on more than one occasion. His house in Mellanby Crescent however, does not stand on any older property so who or why this spirit is there is as big a mystery as the question of why there is a ghost there at all. I have heard of many similar ghost stories, one of which comes from a good friend of mine, not prone to telling strange tales. One day at his house in Havelock Close he was making his way to his bedroom – after using the bathroom – when he saw someone pass by him. Height wise, it was the same as his little brother and that is who he thought it was, however as he entered the room he saw his brother sitting on the bed playing on his games console; his parents at the time were out shopping. My friends own theory is that it was the ghost of the old lady who lived there previously. My friend has since moved out of that house, but his parents still live there.

Interesting ghost stories to say the very least; which raises the question by C. J. – quite rightly so – as to why the ghost may indeed reside at these premises. He clearly states that there was nothing built on the site prior to this house, which is fair enough but the thought occurs that whoever is haunting the house may have actually *died* on the spot where the house stands hundreds of years previously, and therefore nowadays haunts the scene of his death. Were the gallows on this spot at one time perhaps? Is the land where the housing estate is now part of an old battlefield? Or perhaps, could there be any records of murder most foul in this vicinity? And if so, does the murder victim's description match up with the phantoms? These are the questions that should be asked. More importantly, I feel that to get to the bottom of any haunting or apparition sighting, we should try to identify who the ghost is. Once his identity is established, then the rest should hopefully fall into place. Of course, this is all so very easy in theory!

Another recorded sighting on C. J.'s website is the ghost of a lady who wears a white dress. He says,

> The A167 is said to be haunted, and I have only found one fairly unreliable online source for this story, but two separate people contacted me saying they had seen her standing close to the Gretna public house/restaurant.

I was very much intrigued by the fact that he said two other people contacted him with their own accounts of this ghost, so I asked C. J. if he could relay to me what they had told him. He got in touch with the following information;

> A couple of people contacted me by telephone a few years ago now. I did make some notes at the time but both witnesses said that they would prefer to remain anonymous so I made no record of their names. They both said that they had seen a woman dressed in a white mini-skirt with a short 1960s-style hair-do. One of my informants said that she wore white boots which reached halfway up her lower leg. Both saw the

The Gretna Green public house in Newton Aycliffe; two reports have come in saying that a ghost girl dressed in 1960s attire has been seen standing close by this pub. (*Picture courtesy of Christopher J. Linton*)

The T-junction close to the Gretna Green pub where the 1960s ghost girl was actually seen. (*Picture courtesy of Christopher J. Linton*)

woman on their way to work in the early hours of the morning when it was still dark. Could they have simply seen a real flesh-and-blood person and assumed it may have been a ghost? Possibly; although this ghost is fairly well known throughout this area, not many people know the actual full details. Eerily, the actual ghost that has been seen here is indeed someone dressed in '60s style clothing with matching hair.

C. J.'s next ghost account is nothing more than hearsay and myth. He readily admits this is indeed the case.

The railway line from Bishop Auckland to Darlington runs close to Greenfield School. This is part of the same line which runs from Stephenson's work yards at Shildon to Darlington. In the very early days of steam travel, men on horseback would ride ahead of the trains making sure no cattle had wandered onto the track or indeed any people. These men would often ring a bell as a way of warning. About midway between Greenfield School and Newton Aycliffe train station the ghost of one of these bell-men is said to haunt the area of line where he fell from his horse and hit his head on the tracks. This is local legend and no such event has been recorded, however people have contacted me and said they have heard a horse whinnying and clopping on the stones, all the while a bell is ringing.

This is a classic example of potential autosuggestion and how ghost tales could be perpetuated through time simply because people *think* that there is a ghost there in the first place. This is something that every investigator or aficionado of the paranormal must take into account when researching spooky stories. The fact that C. J. has investigated this case and categorically states that no death of this nature was ever recorded there could prove this beyond all doubt. The fact that people have contacted him with alleged spooky accounts is probably the result of them *believing* the area is haunted, forcing them to come to an automatic paranormal conclusion regarding the sights or sounds they heard when in that area; it's easily done!

However, not wanting to pour cold water over these accounts I think I should mention that just because records do not exist of a certain event doesn't mean to say that the event never occurred in the first place. How many deaths have occurred over the years that have been hidden from the authorities and never documented for whatever reasons? Murders, accidents, even natural deaths … The likelihood is that no such death occurred here, but just suppose that it did, and those that witnessed it decided to cover up the accident for reasons only known to them? Whenever there is a big secret to be kept you can pretty much guarantee that someone will blab… So this could be where the original tale of what really happened originated, passed on down the generations to the present. All theory and hypothesis, but I have learned nowadays to never say never.

Moving on to C. J.'s next tale of supernatural activity in the Newton Aycliffe area: Because of the risk of offending or upsetting any local people I can only say the next haunted location is one of Newton Aycliffe's many old people's homes. My grandmother worked there for around ten years, my mother for around ten years and even one of my sisters for around five years. At least once a month I would hear about

The stretch of railway line between Bishop Auckland and Darlington said to be haunted by a former 'bellman' that was said to have fallen from his horse and hit his head although local researcher C. J. Linton admits that he cannot find any evidence to support this theory. (*Picture courtesy of Christopher J. Linton*)

a new sighting or paranormal occurrence. The building is made up of two floors; the ground floor has recreation and social rooms, cleaning and laundry, and of course the dining room. The first floor is made up of the residents' own rooms with a smaller social room at the end of a long corridor. A majority of the phenomena are associated with this small social room. Witnesses have told of standing at one end of the corridor and seeing an old man standing in the doorway at the other end which led to the social room. Thinking one of the residents was out of bed they would go to the room and find it empty, with the only egress routes being a fire escape or the corridor itself.

On one occasion two women at simultaneously saw a white misty form moving in the room. They departed quickly and didn't go back onto that floor for a while. Some other staff members who contacted me told of seeing some of the furniture in this room moving around on its own. On one occasion a plant pot slid off a windowsill and broke on the floor, and when a staff member went to get some cleaning equipment she came back to find that the soil from the plant pot had been shaped into a crescent moon shape. As well as this room at least one of the residential rooms is also haunted. My own sister was locked inside the room when she was in fact the only person on the first floor during a resident's day trip out. Whilst she was cleaning the resident's bed, the door slammed shut behind her and she could not turn the handle as though someone was holding it from the outside.

Absolutely fascinating, don't you think? It is indeed a truism that rest homes or elderly residential homes are often haunted but normally by some of residents that

lived out their final days there. I know of a few of these homes that are alleged to be haunted; in fact a good friend of mine, Suzanne Hitchinson (a fellow ghost hunter and medium), works at one of these homes and is often told stories by her workmates of paranormal encounters that have occurred there. Past residents have been seen walking the corridors, objects have been known to have been moved about in an unexplained manner, and voices are heard in areas when the staff are working alone; voices that are recognised as past tenants. There are, of course, a number of explanations as to why these homes are haunted by the folk that once lived there, one being the old clichéd explanation is that they loved their final home so much they want to reside there in the afterlife. Another reason for so much ghostly activity being reported is simply because it is believed that the staff that work in places such as these are more 'in tune' with the spirit world than most other people therefore seeing and sensing things that most people would not. Whatever the explanation, it is true to say that residential homes are indeed a magnet or a gathering place for those that have passed on.

Moving on to more conventional and better known hauntings; C. J. states:

Darlington Civic Theatre is haunted by one of its previous owners and his dog! I have been fortunate enough to spend a night in the theatre as part of a Paranormal Company's investigation and I did see and hear some strange phenomena which I cannot explain. The first was while I was sitting in the middle stalls. Behind us was a door leading to the bar area which we could partly see through. While sitting in the seats myself and my colleagues heard what I can only describe as the door being kicked. We all jumped up and had a good look around the area we were in and the bar, and found no one around! Later on, the whole group were on the stage when suddenly a number of the individuals partaking in that night's investigation – who were all looking the same way, saw a flash of light from the opposite side of the stalls. Other ghosts which supposedly haunt the place are a fly man (they would work the ropes which moved scenery about etc.) and an old nightwatchman, although descriptions of this ghost might be influenced by a large photograph of a similar-looking gentlemen close to the toilets. The Kings Head Hotel is a very popular place for visitors; sadly damaged in a recent fire it has always had its strange tales associated with it. Mainly on the fourth floor the tales centre around shadows being seen flitting from room to room, one paranormal company claimed to have seen the ghost of a young girl dressed in Victorian clothing, replete with bonnet and bow tied under her chin.

From orthodox tales of ghosts – if indeed ghost stories can be labelled 'orthodox' – to unorthodox tales of little people, elves and fairies. People have long believed the existence of such creatures, or elemental spirits as they are sometimes called. Accounts of these fairy folk have come in steadily over the years. Of course, a lot of people dismiss this notion as outright nonsense and will not under any circumstances begin to even accept the *possibility* of their existence. Fairy stories are exactly what they are, aren't they? Simply stories about fairies; however, if we look back through history and study early folklore and paranormal accounts, these elemental beings always seem to raise their heads and get discussed or mentioned. Indeed, the south-central County Durham town known as Ferryhill was once believed to be the site of a huge fairy population that

Darlington Civic Theatre is said to be haunted by one of its previous owners – and his dog!

The Kings Head Hotel in Central Darlington has an eerie reputation for being haunted. It was once claimed that one individual saw the ghost of a young girl dressed in Victorian clothing, replete with bonnet and bow tied under her chin.

lived underground in an area which was then known as 'Fairy Hill'. As you can see, the present name of this town is not that different nowadays and derived from the old area where people actually believed these wonderful little winged creatures lived.

The legendary novelist, philosopher, crime writer and supernaturalist Colin Wilson is one of the few paranormal investigators that firmly believes in elemental spirits such as pixies and fairies, and subsequently admits this in the foreword that he has penned for a new book that Mike Hallowell and I have written. Colin has for many years studied countless cases of such sightings and has evaluated some of the world's most astonishing evidence that supports the notion of these beings having an objective reality. Personally, I would love to think that fairies are real and do exist in the bottom of our gardens and in deep, dark, dingy dells in dense woodland, but sadly the evidence does not *yet* convince me. Perhaps I should delve a little more into this magical and unseen world of the little folk and make another decision when I have actually studied the evidence properly. Indeed, this is a lesson that most people should learn. County Durham of course has its fair share of fairy tales and C. J. has done a fantastic job in compiling them...

Slightly further away is Bishopton Castle Hill, lying just outside the village of Bishopton. The Castle Hill is a very well-preserved motte-and-bailey earthwork. Originally made of wood the castle and its palisade defences have long since gone leaving only the earthwork remains. It was built in the early twelfth century when Bishop Ranulf gave the land to Roger Conyers. Soon the Bishop of Durham was usurped by a man called William Comyn. Many local barons paid Comyn homage as the new Bishop; Conyers, however, did not, and awaited the rightful bishop to come north and take the Bishopric back. Eventually Comyn was defeated and the Conyers family prospered due to their support of the true Bishop. Bishopton, however, was not their main seat of power and so the Castle was left to be stripped of its wood. It is here that the legend of Bishopton was created. It is said that anyone who spends a night on the hill will be chased off by a group of Fairies. Certain legends differ with regards to why these fairies are here, some claiming they moved in when everyone else moved out and didn't like idea people taking down their home. Others say that they have always been there and they fought alongside Conyers' during the troubles of the early twelfth century. Closer to where I live in Newton Aycliffe there is a much more remarkable fairy story, that of the Middridge Fairies; a story I heard whilst at primary school. The village of Middridge lies between Shildon and Newton Aycliffe and is a charming place to live. To the north of the village there is a strange hole in the earth and no one knows how it became. Legend has it that if you run around the hole backwards, at the same time saying the Lord's Prayer... an evil fairy – or even the Devil himself – will come out of the hole and chase you until you are home. If it catches you, you will be killed. It is alleged that in the early 1900s a group of farm boys dared one another to do this and something did indeed come out of the ground and chase them to their farm. As they ran into a barn they slammed the door shut behind them and then heard a mighty crash as though a thunderbolt had hit the barn. Upon opening the door they found a trident impaled in the door. As they pulled it out it vanished but left the scorched trident mark in the door. It is said the door found its way to the local public house (The Bay Horse) which put it on show but it soon vanished, never to be seen again.

Bibliography, Sources and Recommended Reading

Day, James Wentworth, *In Search of Ghosts* (Muller, 1969)

Hallowell, Michael J. & Ritson, Darren W., *Ghost Taverns* (Amberley)

Hallowell, Michael J., *Christmas Ghost Stories* (Amberley)

Hallum, Jack, Ghosts of the North (David & Charles, 1976)

Hapgood, Sarah, *500 British Ghosts and Hauntings* (Foulsham, 1993)

Harries, John, *The Ghost Hunter's Road Book* (Letts, 1968)

Hippisley Coxe, Antony A., *Haunted Britain* (Pan, 1973)

Hugill, Robert, *Castles of Durham* (Frank Graham, 1979)

Kirkup, Rob, *Ghostly County Durham* (The History Press, 2010)

MacKenzie, Andrew, *Hauntings and Apparitions* (Heinemann, 1982)

Maple, Eric, *Supernatural England* (Hale, 1977)

O' Donnell, Elliot, *Haunted Britain* (Rider, 1948)

Poole, Keith B., *Haunted Heritage* (Guild Publishing, 1988)

Puttick, Betty, *Supernatural England* (Countryside Books, 2002)

Folklore, *Myths and Legends of Britain* (*Reader's Digest*, 1973)

Ritson, Darren W., *Haunted Newcastle* (The History Press, 2009)

Ritson, Darren W., *Ghost Hunter, True Life Encounters from the North East* (GHP, 2006)

Ritson, Darren W., *In Search of Ghosts, Real Hauntings from Around Britain* (Amberley, 2008)

Underwood, Peter, *This Haunted Isle* (Harrap, 1984)

Underwood, Peter, *A Gazetteer or British Ghosts* (Souvenir Press, 1971)

Websites

http://www.darlington.gov.uk/Environment/Countryside%20and%20Rights%20of%20Way/Parks/southpark/History.htm

Capital Punishment UK – http://www.capitalpunishmentuk.org/contents.html

The Paranormal Database – http://www.paranormaldatabase.com/

David Simpson – http://www.northeastengland.talktalk.net/DavidSimpsonHistory.htm

API – http://www.anomalous-phenomena-investigations.co.uk/

http://www.freewebs.com/paranormalhistory/

http://www.englandsnortheast.co.uk/index.html

http://www.barnardcastlelife.co.uk/castlehistory.html